STAR WARS

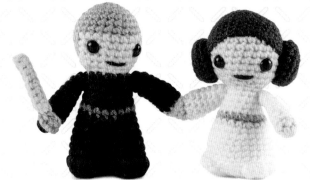

CROCHET

LUCY COLLIN

ThunderBay
P·R·E·S·S

SAN DIEGO, CALIFORNIA

D1501249

Thunder Bay Press
An imprint of Printers Row Publishing Group
A division of Readerlink Distribution Services, LLC
10350 Barnes Canyon Road, Suite 100, San Diego, CA 92121
www.thunderbaybooks.com

Printers Row Publishing Group is a division of Readerlink Distribution Services, LLC.
The Thunder Bay Press name and logo are trademarks of Readerlink Distribution Services, LLC.

All notations of errors or omissions should be addressed to Thunder Bay Press, Editorial
Department, at the above address. All other correspondence (author inquiries, permissions)
concerning the content of this book should be addressed to becker&mayer! Books, 11120 NE 33rd
Place, Ste. 101, Bellevue, WA 98004.

This book is part of the *Star Wars Crochet* kit and is not to be sold separately.

Produced by becker&mayer! LLC
Bellevue, Washington

www.beckermayer.com

Designer: Rosebud Eustace
Editor: Delia Greve
Photographer: Joseph Lambert
Production coordinator: Jennifer Marx
Product development: Peter Schumacher

Project # 15245

ISBN-13: 978-1-62686-326-2
ISBN-10: 1-62686-326-1

Printed, manufactured, and assembled
in Shenzhen, China.

19 18 17 16 15 2 3 4 5 6

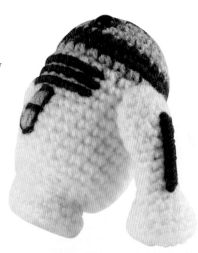

CONTENTS

Introduction

I hope you enjoy making these adorable characters as much as I have. Small, fairly simple, and quick to make, they can be used as gifts, toys, or decorations. I've made them for friends and relatives, as well as for teenagers and adults in their fifties!

They're especially great for children—kids can carry around their favorite characters in their pockets or be kept busy with these characters when you go out. You can make the whole set (and maybe a few extra stormtroopers) so kids can set up scenes or have big adventures in their rooms.

You could also turn the characters into a baby's mobile, hang them in your car, make one into a keychain, add Santa hats and hang them on your Christmas tree, or even make Han and Leia (or whichever pair you like best) as wedding cake toppers. Have fun and, of course, may the Force be with you!

About This Kit

All twelve featured figures are made in rounds from the top of the head down, with parts such as arms and ears made separately. Do not join rounds. Work through both loops of stitches unless otherwise indicated.

What's Included

This kit contains the materials you will need to make one Stormtrooper and one Yoda. Included are the following: a size E/4 (3.5 mm) crochet hook; a metal tapestry needle; yarn in colors white, black, beige, pale green, and brown; four black plastic safety eyes; and stuffing.

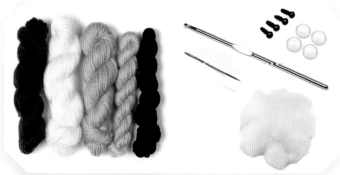

4

ABBREVIATION CHART

ch	chain
st	stitch or stitches
sl st	slip stitch
sc	single crochet (U.S.), double crochet (U.K.)
hdc	half-double crochet (U.S.), half treble (U.K.)
dc	double crochet (U.S.), treble crochet (U.K.)
bob	bobble (see Special Stitch Instructions, page 14)
pop	popcorn stitch (see Special Stitch Instructions, page 14)
spike	spike stitch (see Special Stitch Instructions, page 14)
tog	together
sc2tog	decrease by working two sc together
BLO	back loop only
FLO	front loop only
FO	fasten off
YO	yarn over

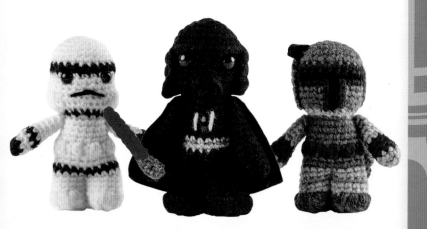

Notes

YARN
These figures have been made using worsted weight yarn (4: medium) or double knitting weight yarn (3: light). It is best to use the same weight of yarn throughout a project and to stick to the same brand of yarn if possible. The amounts given in each pattern are approximate and may vary depending on the type of yarn used, so make sure you get enough yarn to complete each project. The patterns work best if you use acrylic yarn or acrylic with some wool content.

STITCH MARKERS
Using a stitch marker to indicate the start of a round can be helpful. You can buy plastic ones or use paper clips or safety pins; you can also use a small piece of contrasting yarn. You will also need a clip-type stitch marker to secure the working loop when you set a project aside. It is best to place the marker under the stitch at the start of the round.

SMALL PLIERS
A pair of small, flat-nosed pliers that are used in crafts such as jewelry making are useful when you're sewing parts together. Pliers can be used to grasp the needle and pull it through if necessary.

PINS
Long, round-headed pins are helpful to secure parts when you're sewing them together.

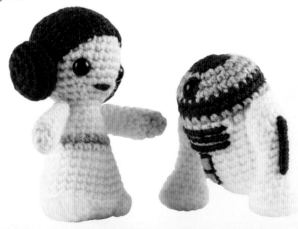

Techniques and Terminology

If you are new to crochet, here are the basics you'll need to know for this book. Making amigurumi (toys worked in the round) is a bit different from making other items using crochet, so if you've never made them before, be sure to read all the instructions so you understand the techniques.

SLIPKNOT

Most crochet starts with a slipknot. Make a circle of yarn a short distance from the end of the piece of yarn and loop over your hook, then tighten into a knot so that the loop moves freely on your hook. (Figs. A & B)

YARN OVER (YO)

To make every stitch, you need to pass the yarn over the hook. Hold the hook in your right hand (if you are right-handed) between your thumb and index finger and lightly clasp the short end of yarn in the rest of your fingers. Hold the rest of the yarn in your left hand, catching it around the back of your index finger, and pass it around the back of the hook and over the front so it gets caught in the hook at the end.

Fig. A

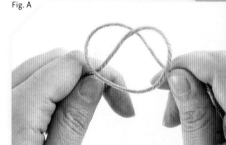

CHAIN STITCH (CH)

YO, catch hold of the short end of yarn with your left thumb and middle finger, and pull the yarn through the loop on the hook. This makes one chain stitch—it's a good idea to practice this a lot to get used to holding the hook and yarn. (Fig. C–page 8)

Fig. B

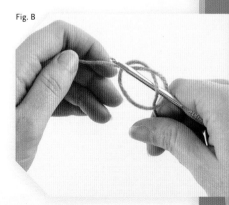

WORKING INTO THE CHAIN

To work into the chain, turn the chain and start working into it from the end nearest the hook. (Fig. D–page 8) If you look at the

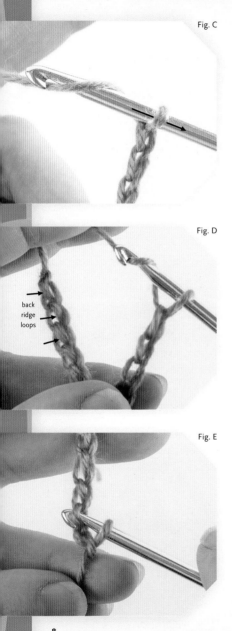

Fig. C

Fig. D

back
ridge
loops

Fig. E

chain, you will see that each chain stitch consists of two lines making a sideways "v" shape, with another line behind them (the bump). You usually skip the chain nearest the hook (this is always stated in the patterns) and then push the hook between the "v" and below the bump. (Fig. E)

When making amigurumi, you do not need to work into the chain very often, but you should learn how as you will need to do it when you make Yoda's robe, Boba Fett's cape, and other parts that are worked in rows rather than rounds.

WORKING INTO A STITCH

All stitches are the same at the top; they have two lines that make a sideways "v" shape. Each of these lines is called a loop. To work into a stitch, insert your hook under both loops from the front to the back.

BACK LOOP ONLY (BLO)

Insert your hook under the back of the two loops (the one farthest away from you as you are facing your work), that make the stitch you are working into. Continue with the stitch as normal. (Fig. F)

FRONT LOOP ONLY (FLO)

Insert your hook under the front of the two loops (the closest one to you as you are facing your work), making the top of the stitch you are working into. Continue with the stitch as normal.

SLIP STITCH (SL ST)

This is a very flat stitch that is not used often, but is sometimes necessary to neaten up your work. Push the hook into the ch or st, YO, (Fig. G) pull through ch or st and loop on hook.

SINGLE CROCHET (SC)

This is the stitch you will use most of the time when making amigurumi. Push the hook into the ch or st, YO, pull through ch or st, YO, (Fig. H) pull through both loops on hook.

HALF-DOUBLE CROCHET (HDC)

This is a slightly taller stitch than a sc. YO, push hook into ch or st, YO, (Fig. I–page 10) pull through ch or st, YO, pull through 3 loops on hook.

DOUBLE CROCHET (DC)

This stitch is about twice as tall as a sc. YO, push hook into ch or st, YO, pull through ch or st, (Fig. J–page 10) YO, pull through 2 loops on hook, YO, pull through remaining 2 loops on hook.

INCREASING AND DECREASING

To make what you're crocheting larger or smaller, you increase or decrease. To increase, work two stitches (in these patterns that will always be sc) into the same stitch or chain. (Fig. K–page 10) To decrease,

Fig. F

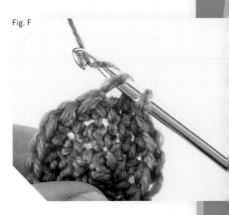

Fig. G

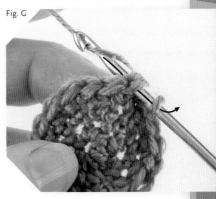

Fig. H

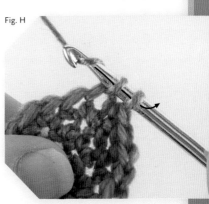

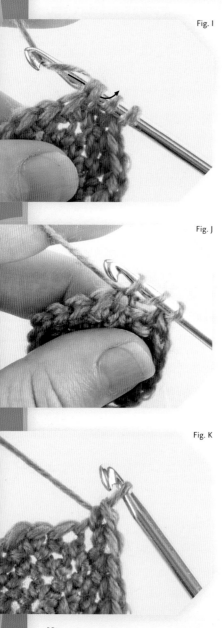

Fig. I

Fig. J

Fig. K

work into two stitches at once and end up with only one stitch, as described next with a sc2tog.

SINGLE CROCHET TWO TOGETHER (SC2TOG)

Push hook into st, YO and pull through st, push hook into next st, YO and pull through st, YO and pull through 3 loops on hook. (Fig. L)

INVISIBLE DECREASE

This gives a neater look when you decrease, so it is especially good to use on faces. Push hook through the front loop of st, push hook through the front loop of next st, YO and pull through 2 loops on hook, YO and pull through 2 remaining loops on hook.

FASTEN OFF (FO)

When you finish a piece of crochet, cut the yarn, leaving a length of about twelve inches (or however much the pattern calls for) and pull this yarn through the stitch. This yarn will then be used to sew pieces together, or it will be sewn through the fabric to secure the yarn (see Weave In Ends, page 14).

ROWS

To make a flat piece of crocheted fabric, make a chain of a certain length then work into that chain. Turn your work at the end of the row and continue with the next row in the opposite direction. Continue working rows backward and forward as necessary for the pattern. (Fig. M)

ROUNDS (RND)

To make a three-dimensional piece of crochet, such as the figures in this book, work a number of stitches into one stitch (see also Adjustable Ring, below), making a small circle. Continue with the next round by working the next stitch into the first stitch of the first round and so on around the circle (with increases if necessary). (Fig. N) These rounds are continuous, so you will not be able to see the start of each round unless you mark it. Use a stitch marker or a small piece of contrasting yarn.

STARTING THE FIRST ROUND

Ch 2, then work the number of sc in the first round (generally 6) into the first ch. Work the sc over the tail of yarn as well and use that to pull the hole tight.

ADJUSTABLE RING

This is an alternate way to start the first round. Make a loop around the first and second fingers of your right hand. Remove it from your fingers and put the hook through the loop. (Fig. O–page 12) YO and pull through. YO and pull through loop on hook, pulling tight. Then work the number of sc in the first round around the loop of yarn. (Fig. P–page 12) At the end of the first round, pull the end of the yarn tight to make a neat circle with no hole in the middle.

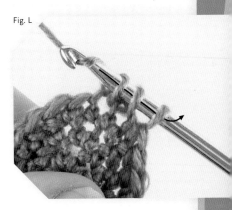

Fig. L

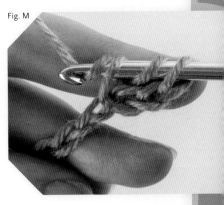

Fig. M

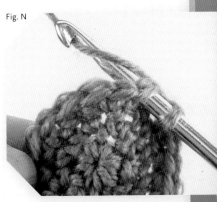

Fig. N

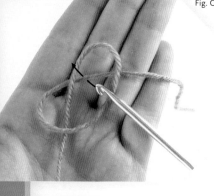
Fig. O

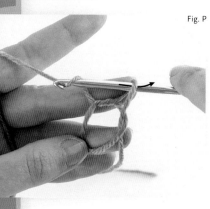
Fig. P

RIGHT SIDE AND WRONG SIDE

When working in rows, there isn't always a clear right or wrong side to the fabric. When working in rounds, however, there is an obvious inside and outside. As you start to crochet a rounded shape, the side that is facing you as you work is the right side. As the fabric becomes bowl-shaped, it should be on the other side of your hook as you are crocheting. If you are working inside-out, your work will be between you and your hook. You can see the difference between the two sides—the right side (outside) is smoother and has distinct lines between the rounds that you can easily count. The wrong side (inside) has a rougher texture and less distinct lines. (Fig. Q)

When you are working on a small part, like an arm, it is easy to end up working inside out. After a few rounds use the blunt end of your

RIGHT SIDE WRONG SIDE

Fig. Q

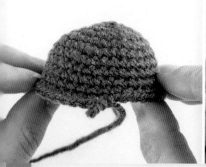

crochet hook to push the part the right way around. While there's nothing bad in general about crocheting wrong-side out, some elements of the pattern may not work or may look strange.

TENSION

When crocheting in the round to make amigurumi, you need to crochet each stitch quite tightly so that the fabric won't stretch to let the stuffing show through—but not so tightly that you can't work into the stitches on the next round. When you make pieces in rows, such as Yoda's robe, you can work a bit more loosely.

CHANGING YARN COLORS

When changing from one color of yarn to another, work up to the change until there are two loops left on the hook. Then use the new color for the final YO and pull through. Work a few sc over the tails of the end of the old yarn and the start of the new yarn to secure them. For places where there is a change to a new color and then back to the original one in the same row, carry the color you are not using behind your work by working over it every three stitches so that the color does not show through—but be careful not to pull the carried yarn too tight or it will affect the shape of the figure. (Fig. R)

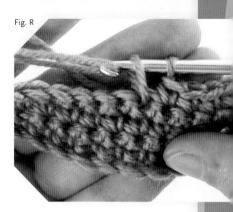

Fig. R

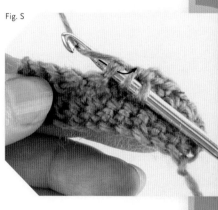

Fig. S

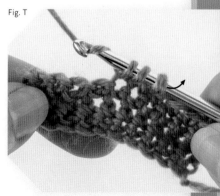

Fig. T

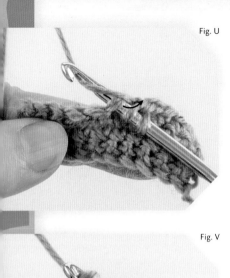

Fig. U

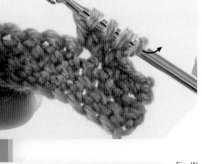

Fig. V

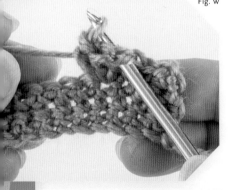

Fig. W

CONSTRUCTION

Use yarn tails from the completed pieces to sew on parts such as arms. Pin the smaller piece to the larger piece and sew through the top of each stitch on the smaller piece into the larger piece.

WEAVE IN ENDS

When you work in rounds, most of the ends of yarn get left on the inside of the figure, so you don't need to worry about them. On flat pieces, you need to neaten up any loose ends by sewing through a few stitches and back again to keep the ends from unraveling.

SPECIAL STITCH INSTRUCTIONS

BOBBLE STITCH, 2DC (2DC BOB): YO, insert hook into next stitch, YO and pull through loop (Fig. S–page 13), YO, pull through 2 loops, YO, insert hook into same stitch, YO and pull through loop, YO, pull through 2 loops, YO, pull through all 3 loops on hook. (Fig. T–page 13)

BOBBLE STITCH, 3DC (3DC BOB): YO, insert hook into next stitch, YO and pull through loop (Fig. U), YO, pull through 2 loops, *YO, insert hook into same stitch, YO and pull through loop, YO, pull through 2 loops, repeat once from *, YO, pull through all 4 loops on hook. (Fig. V)

Fig. X

POPCORN STITCH, 3DC (3DC POP): Work 3dc into one st, remove hook from working loop, push through both loops of first dc and pull working loop through. (Fig. W)

SPIKE STITCH, SC (SPIKE SC) Insert hook into space between stitches one row/round below working stitches, YO, pull through space between stitches, YO, pull through both loops on hook. (Fig. X)

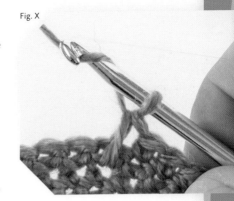

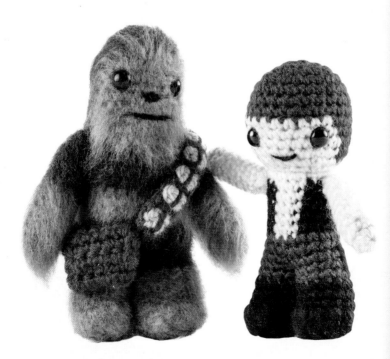

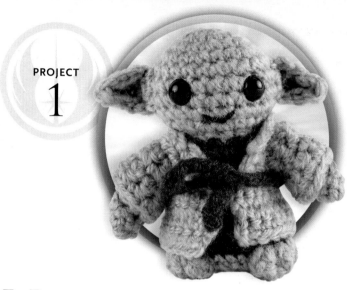

YODA

FINISHED SIZE: approximately 2.5" tall

Once leader of the Jedi Council, Yoda retired to the swamps of Dagobah. Despite his unassuming appearance, he is a powerful and wise old Jedi. It is Yoda who will train Luke in the ways of the Force.

MATERIALS

- Pale green yarn (approx. 0.5 oz/15 g)
- Brown yarn (approx. 0.5 oz/15 g)
- Beige yarn (approx. 0.5 oz/15 g)
- Small amount of black yarn (for mouth)
- E/4 (3.5 mm) hook

- Tapestry needle
- Pair of black plastic safety eyes (7.5 mm)
- Stuffing
- Stitch marker

HEAD AND BODY: Start with pale green yarn.

Rnd 1: ch 2, work 6 sc into first ch—6 st.

Rnd 2: 2 sc in each st around—12 st.

Rnd 3: [2 sc in next st, sc in next st] 6 times—18 st.

Rnd 4: [2 sc in next st, sc in next 2 st] 6 times—24 st.

Rnds 5–8: (4 rounds) sc in each st around—24 st.

Rnd 9: [sc2tog, sc in next 2 st] 6 times—18 st.

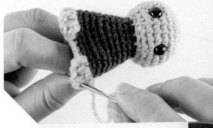

Fig. A

- Fit eyes between rounds 6 and 7, 5 stitches apart, positioning the start of the rounds at the back of the head.

Rnd 10: [sc2tog, sc in next st] 6 times—12 st.

- Change to brown yarn.

Rnd 11: [2 sc in next st, sc in next st] 6 times—18 st.

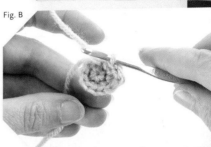

Fig. B

Rnds 12–14: (3 rounds) sc in each st around—18 st.

Rnd 15: [2 sc in next st, sc in next 5 st] 3 times—21 st.

Rnd 16: [2 sc in next st, sc in next 6 st] 3 times—24 st.

Rnd 17: sc in each st around—24 st.

Rnd 18: [2 sc in next st, sc in next 7 st] 3 times—27 st.

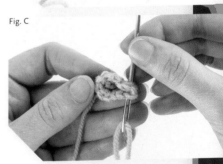

Fig. C

Rnd 19: sc in each st around—27 st.

- Stuff head now.

To make the feet: Find the stitch in the previous round that is in the front-middle of Yoda. Then count back 5 stitches before that (not including the middle stitch) and mark this stitch.

- Change to pale green yarn.

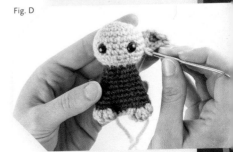

Fig. D

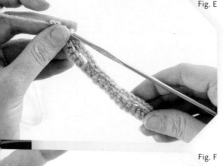

Rnd 20: in BLO, sc in each st around until you get to the marked stitch. Work a 3dc pop in each of next 3 st, sc in next 5 st, work a 3dc pop in each of next 3 st. Sc in each st around to the end of the round—27 st.

- Use beige yarn to embroider claws with a couple of small stitches on each popcorn stitch. Finish stuffing head and body as firmly as you can. Use black yarn to sew a small mouth. (Fig. A–page 17)

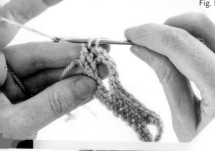

Rnd 21: [sc2tog, sc in next st] 9 times—18 st.

Rnd 22: [sc2tog, sc in next st] 6 times—12 st.

Rnd 23: [sc2tog] 6 times—6 st. FO, leaving a length of yarn.

- Finish stuffing.

- Neatly sew up the hole at the base, pulling the yarn up through the body tightly to make sure the base lies flat. Take the yarn through the body a couple of times to secure the yarn before cutting it.

ARMS (make 2): Start with pale green yarn.

Rnd 1: ch 2, work 6 sc into first ch—6 st.

Rnd 2: sc in each st around—6 st.

- Change to dark brown yarn.

Rnd 3: [2 sc in next st, sc in next 2 st] 2 times—8 st.

Rnds 4–7: (4 rounds) sc in each st around—8 st.

Rnd 8: [sc2tog, sc in next 2 st] 2 times—6 st.

- To finish, sl st in next st, then FO, leaving a length of yarn.

- Do not stuff. Sew the arms to the body.

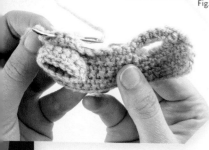

EARS (make 2): Pale green yarn.

Rnd 1: ch 2, work 6 sc into first ch—6 st.

Rnd 2: 2 sc in each of next 3 st, (hdc, dc) in next st, (dc, hdc) in next st, sl st in next st—11 st. (Fig. B–page 17)

• FO, leaving a length of yarn. Weave in the yarn left from the start. Use the length of yarn from the end to sew the pointed end of the ear together with a couple of stitches (Fig. C–page 17) and then work the yarn through to the other end of the ear to attach it to Yoda's head. (Fig. D–page 17)

ROBE: Beige yarn.

• Ch 17.

Row 1: 2 sc in second ch from hook, sc in next 14 ch, 2 sc in next ch, ch 1, turn—18 st.

Row 2: sc in next 2 st, ch 5, skip next 4 st, sc in next 6 st, ch 5, skip next 4 st, sc in next 2 st, ch 1, turn—20 st. (Fig. E)

Row 3: 2 sc in next st, sc in next st, work 5 sc around ch 5, sc in next 6 st, work 5 sc around ch 5, sc in next st, 2 sc in next st, ch 1, turn—22 st. (Fig. F)

Row 4: 2 sc in next st, sc in next 6 st, 2 sc in next st, sc in next 6 st, 2 sc in next st, sc in next 6 st, 2 sc in next st, ch 1, turn—26 st.

Row 5: sc in next 26 st, ch 1, turn—26 st.

Row 6: sc in next 8 st, 2 sc in next st, sc in next 8 st, 2 sc in next st, sc in next 8 st—28 st.

Row 7: sc in next 28 st.

• FO and weave in any loose ends.

ROBE SLEEVES (make 2): Beige yarn.

• Ch 11.

Row 1: sc in second ch from hook, sc in next 9 ch, ch 1, turn—10 st.

Row 2: sc in next 10 st, ch 1, turn—10 st.

Row 3: 2 sc in next st, sc in next 8 st, 2 sc in next st, ch 1, turn—12 st.

Row 4: sc in next 12 st—12 st. (Fig. G)

• FO, leaving length of yarn.

• Fold each sleeve in half and sew edges together, making a tube that is wider at one end than the other. With the seam facing down, pin the narrower end of each sleeve into an armhole and sew in place. (Fig. H) Weave in any loose ends.

BELT: Brown yarn.

• Ch 30, FO and weave in ends. Tie around waist.

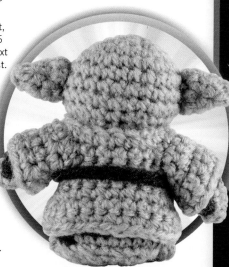

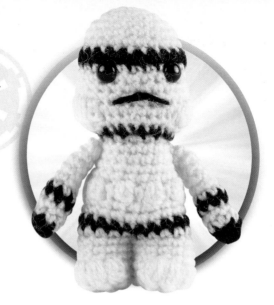

STORMTROOPER

FINISHED SIZE: approximately 3.5" tall

These dedicated soldiers are found all over the galaxy in service of the Empire. Clad in their white armor, they are a faceless and intimidating show of Imperial strength, although they are strangely vulnerable to attack by Ewoks.

MATERIALS

- White yarn (approx. 1 oz/25 g)
- Black yarn (approx. 0.2 oz/5 g)
- E/4 (3.5 mm) hook
- Tapestry needle
- Pair of black plastic safety eyes (7.5 mm)
- Stuffing
- Stitch marker

HEAD AND BODY: Start with white yarn.

Rnd 1: ch 2, work 6 sc into first ch—6 st.

Rnd 2: 2 sc in each st around—12 st.

Rnd 3: [2 sc in next st, sc in next st] 6 times—18 st.

Rnd 4: [2 sc in next st, sc in next 2 st] 6 times—24 st.

Rnds 5–6: (2 rounds) sc in each st around—24 st.

Rnd 7: sc in next 6 st, *change to black yarn*, sc in next 12 st, *change back to white yarn,* sc in next 6 st—24 st.

Rnd 8: sc in next 6 st, sc in BLO next (black) 12 st, sc (through both loops) in next 6 st—24 st.

Rnds 9–10: (2 rounds) sc in each st around—24 st.

Rnd 11: [2 sc in next st, sc in next 3 st] 6 times—30 st.

Rnd 12: sc in next 5 st, 2dc bob in next 7 st, sc in next 9 st, 2dc bob in next 7 st, sc in next 2 st —30 st. (Fig. A–page 22)

Rnd 13: [sc2tog, sc in next 3 st] 6 times—24 st.

• Fit eyes underneath horizontal black bar, between rounds 8 and 9, 5 stitches apart.

• Change to black yarn.

Rnd 14: [sc2tog] 12 times—12 st. (Fig. B–page 22)

• Change to white yarn.

Rnd 15: [2 sc in next st, sc in next st] 6 times—18 st.

Rnds 16–19: (4 rounds) sc in each st around—18 st.

Rnd 20: [2dc bob in next st, sc in next st] 9 times—18 st.

• Push the bobbles on the face and belt from the inside so that they stick out, and stuff the head firmly. Use black yarn to sew the "mouth" on the stormtrooper's helmet. Embroider a very shallow, upside-down "v" shape, using two lines of yarn.

Rnd 21: [2 sc in next st, sc in next 5 st] 3 times—21 st.

Rnd 22: sc in each st around—21 st.

• Change to black yarn.

Rnd 23: [2 sc in next st, sc in next 6 st] 3 times—24 st.

• Change to white yarn.

Rnd 24: sc in each st around—24 st.

Rnd 25: [2 sc in next st, sc in next 7 st] 3 times—27 st.

Rnds 26–27: (2 rounds) sc in each st around—27 st.

To make the feet: Find the stitch in the previous round that is in the front-middle of the stormtrooper. Then count back 6 stitches before that (not including the middle stitch) and mark this stitch. (Fig. C–page 22)

Rnd 28: sc in each st around until you get to the marked stitch. Work a 3dc bob in each of next 4 st, sc in next 5 st, work a 3dc bob in each of next 4 st. Sc in each st around to the end of the round—27 st.

NOTE: *The last 3dc bob stitches should fall on the last stitch of rnd 28, but don't worry if it goes onto the first stitch of rnd29. Just start rnd 29 after the last 3dc bob.*

• Push the bobbles that make up the feet from the inside so that they stick out. Finish stuffing head and stuff top half of body firmly; stuff slightly less firmly below the waist.

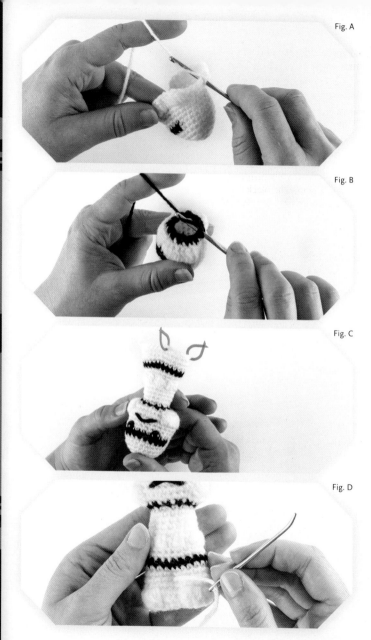

Fig. A

Fig. B

Fig. C

Fig. D

Rnd 29: [sc2tog, sc in next st] 9 times—18 st.

Rnd 30: [sc2tog, sc in next st] 6 times—12 st.

Rnd 31: [sc2tog] 6 times—6 st. FO, leaving a piece of yarn about 24" long.

• Neatly sew up the hole at the base, and then pull the yarn out at the front-middle of the stormtrooper's body, just below the black row. Pull the yarn up tightly to make sure the base lies flat.

• To define the legs, pass the yarn through the body to the same position at the middle back and pull tightly. Pull the yarn back through to the front, one round lower, and again pull tightly. (Fig. D) Continue to do this, working down the legs round by round, until you reach the base of the figure. Take the yarn through the

base (not tightly) a couple of times to secure the yarn and then cut it.

ARMS (make 2): Start with black yarn.

Rnd 1: ch 2, work 6 sc into first ch—6 st.

• Change to white yarn.

Rnd 2: [2 sc in next st, sc in next 2 st] 2 times—8 st.

Rnd 3: sc in each st around—8 st.

• Change to black yarn.

Rnd 4: sc in each st around—8 st.

• Change to white yarn.

Rnds 5–9: (5 rounds) sc in each st around—8 st.

Rnd 10: [sc2tog, sc in next 2 st] 2 times—6 st. Sl st in next st then FO, leaving a length of yarn.

• Stuff arms slightly, then sew the arms to the body.

C-3PO

FINISHED SIZE: approximately 3.25" tall

This protocol droid's devotion to his friend R2-D2 routinely lands him in danger, much to his own horror. But no matter where C-3PO ends up, he tries to be most helpful.

MATERIALS

- Gold yarn (approx. 0.7 oz/20 g)
- Variegated yarn with a mix of at least some gray, brown, black, red, and white (approx. 0.2 oz/5 g)
- Small amount of black yarn (for mouth)
- E/4 (3.5 mm) hook
- Tapestry needle
- Pair of amber plastic safety eyes (7.5 mm)
- Stuffing
- Stitch marker

HEAD AND BODY: Start with gold yarn.

Rnd 1: ch 2, work 6 sc into first ch—6 st.

Rnd 2: 2 sc in each st around—12 st.

Rnd 3: [2 sc in next st, sc in next st] 6 times—18 st.

Rnd 4: [2 sc in next st, sc in next 2 st] 6 times—24 st.

Rnds 5–10: (6 rounds) sc in each st around—24 st.

Rnd 11: [sc2tog, sc in next 2 st] 6 times—18 st.

- Fit eyes between rounds 8 and 9, 5 stitches apart, positioning the start of the rounds at the back of the head. (Fig. A)

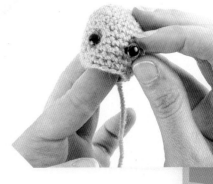

Rnd 12: [sc2tog, sc in next st] 6 times—12 st.

Rnd 13: [2 sc in next st, sc in next st] 6 times—18 st.

Rnds 14–17: (4 rounds) sc in each st around—18 st.

- Stuff head.

- Change to variegated yarn.

Fig. B

Rnd 18: in BLO, sc in each st around—18 st.

Rnd 19: Work 3 evenly spaced increases (2 sc in 1 st). Find the st in the front middle, then count back 6 st before this and mark the st. Sc until you get to that st then work the first increase. [Sc in next 5 st, 2 sc in next st] 2 times, sc in any remaining st—21 st. (Fig. B)

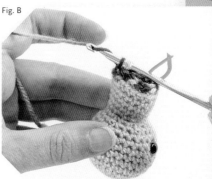

Rnd 20: sc in each sc around—21 st.

- Change to gold yarn.

Fig. C

Rnd 21: [2 sc in next st, sc in next 6 st] 3 times—24 st.

Rnd 22: in BLO, sc in each st around—24 st.

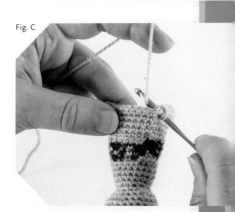

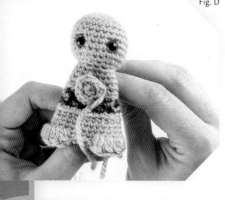

Fig. D

Rnd 23: [2 sc in next st, sc in next 7 st] 3 times—27 st.

Rnds 24–25: (2 rounds) sc in each st around—27 st.

To make the feet: Find the stitch in round 25 that is in the front-middle of C-3PO. Then count back 6 stitches before that (not including the middle stitch) and mark this stitch.

Rnd 26: sc in each st around until you get to the marked stitch. To make feet: Work a 3dc bob in each of next 4 st, sc in next 5 st, work a 3dc bob in each of next 4 st. Sc in each st around to the end of the round—27 st.

- Make sure the bobbles that make up the feet are pushed outward.

- Stuff head and top half of body firmly; stuff slightly less firmly below the waist. Use black yarn to sew a small mouth.

Rnd 27: [sc2tog, sc in next st] 9 times—18 st. (Fig. C—page 25)

Rnd 28: [sc2tog, sc in next st] 6 times—12 st.

Rnd 29: [sc2tog] 6 times—6 st. FO, leaving a piece of yarn about 24" long.

- Neatly sew up the hole at the base, and pull the yarn out at the front-middle of C-3PO, 3 rounds up from his feet. Then pull the yarn up tightly to make sure the base lies flat.

- To define the legs, pass the yarn through the body to the same position at the middle back and pull tightly. Pull the yarn back to the front of the figure, one round lower, and again pull tightly. Continue to do this, working down the legs

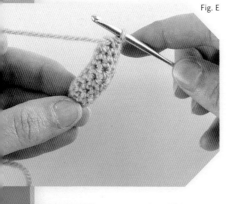

Fig. E

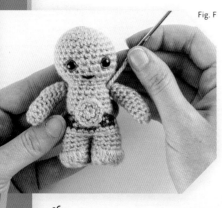

Fig. F

round by round, until you reach the base of the figure. Take the yarn through the base (not tightly) a couple of times to secure the yarn before cutting it.

CHEST PLATE: Gold yarn.

Rnd 1: ch 2, work 6 sc into first ch—6 st.

Rnd 2: 2 sc in each st around—12 st. Sl st in next st then FO, leaving a length of yarn.

• Use this to sew the plate to the front of the body, overlapping with the first two rounds of variegated yarn. (Fig. D)

ARMS (make 2): Gold yarn.

Rnd 1: ch 2, work 6 sc into first ch—6 st.

Rnd 2: [2 sc in next st, sc in next 2 st] 2 times—8 st.

Rnds 3–4: (2 rounds) sc in each st around—8 st.

Rnds 5–6: sc in next 4 st, hdc in next 4 st—8 st.

Rnds 7–9: (3 rounds) sc in each st around—8 st.

Rnd 10: [sc2tog, sc in next 2 st] 2 times—6 st. Sl st in next st then FO, leaving a length of yarn. (Fig. E)

• Stuff lightly and sew to the body, making sure they are positioned with the curve created by the hdc stitches on the outside. (Fig. F)

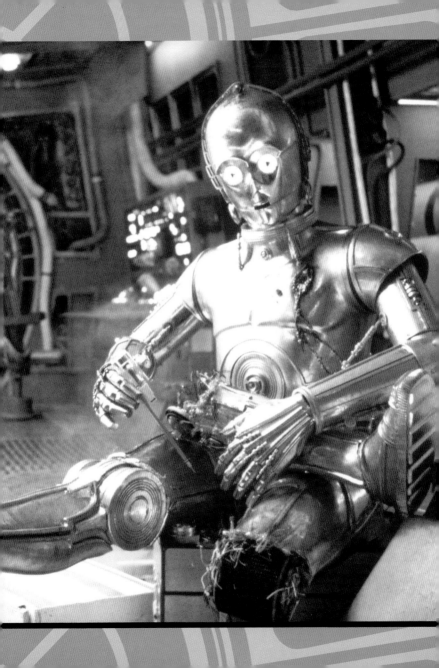

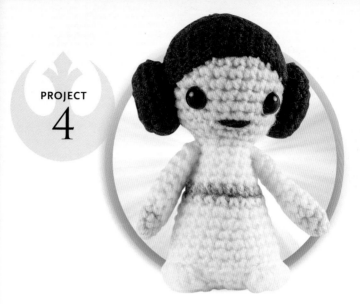

PRINCESS LEIA

FINISHED SIZE: approximately 3.25" tall

As a politician and a diplomat, the young princess is a force to be reckoned with, but she's even more dangerous with a blaster in her hand. As a leader of the Rebel Alliance, she is determined to overthrow the Empire.

MATERIALS

- Dark brown yarn (approx. 0.2 oz/5 g)
- Pale peach yarn (approx. 0.4 oz/10 g)
- White yarn (approx. 0.5 oz/15 g)
- Small amount of silver-gray yarn (for belt)
- Small amount of red yarn (for mouth)

- E/4 hook (3.5 mm)
- Tapestry needle
- Pair of black plastic safety eyes (7.5 mm)
- Stuffing
- Stitch marker

HEAD AND BODY: Start with pale peach yarn.

Rnd 1: ch 2, work 6 sc into first ch—6 st.

Rnd 2: 2 sc in each st around—12 st.

Rnd 3: [2 sc in next st, sc in next st] 6 times—18 st.

Rnd 4: [2 sc in next st, sc in next 2 st] 6 times—24 st.

Rnds 5–11: (7 rounds) sc in each st around—24 st.

Rnd 12: [sc2tog, sc in next 2 st] 6 times—18 st.

- Fit eyes between rounds 9 and 10, 6 stitches apart, positioning the start of the rounds at the back of the head.

Rnd 13: [sc2tog, sc in next st] 6 times—12 st.

- Change to white yarn.

Rnd 14: sc in each st around—12 st. (Fig. A)

Rnd 15: [2 sc in next st, sc in next 3 st] 3 times—15 st.

Rnds 16–17: (2 rounds) sc in each st around—15 st.

Rnd 18: [2 sc in next st, sc in next 4 st] 3 times—18 st.

- Stuff head.
- Change to silver-gray yarn.

Rnd 19: sc in each st around—18 st.

- Change to white yarn.

Rnd 20: [2 sc in next st, sc in next 5 st] 3 times—21 st.

Rnd 21: sc in each st around—21 st.

Rnd 22: [2 sc in next st, sc in next 6 st] 3 times—24 st.

Rnd 23: sc in each st around—24 st.

Rnd 24: [2 sc in next st, sc in next 7 st] 3 times—27 st.

Fig. A

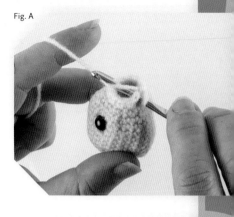

Fig. B

Fig. C

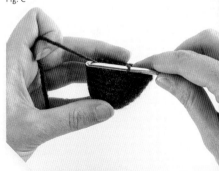

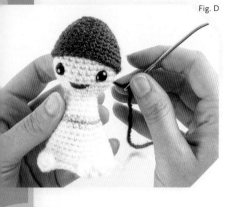
Fig. D

Rnds 25–26: (2 rounds) sc in each st around—27 st.

To make the feet: Find the stitch in Rnd 26 that is in the front-middle of Leia. Then count back 6 stitches before that (not including the middle stitch) and mark this stitch.

Rnd 27: in BLO, sc in each st around until you get to the marked stitch. Work a 3dc bob in each of next 4 st, sc in next 5 st, work a 3dc bob in each of next 4 st. Sc in each st around to the end of the round—27 st.

- Use red yarn to sew a small mouth: Sew one line for her top lip, then sew a slightly shorter line underneath the first for her bottom lip. (Fig. B–page 31)

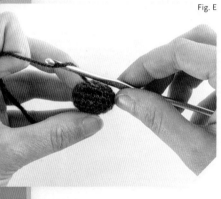
Fig. E

- Make sure the bobbles that make up the feet are pushed outward, then finish stuffing head and body as firmly as you can. Continue stuffing as you go.

Rnd 28: [sc2tog, sc in next st] 9 times—18 st.

Rnd 29: [sc2tog, sc in next st] 6 times—12 st.

Rnd 30: [sc2tog] 6 times—6 st. FO, leaving a length of yarn.

- Neatly sew up the hole at the base, pulling the yarn up through the body tightly to make sure the base lies flat. Take the yarn through the body a couple of times to secure the yarn before cutting it.

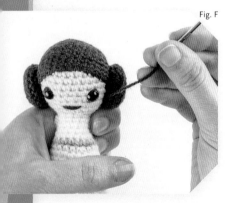
Fig. F

HAIR: Dark brown yarn.

Rnd 1: ch 2, work 6 sc into first ch—6 st.

Rnd 2: 2 sc in each st around—12 st.

Rnd 3: [2 sc in next st, sc in next st] 6 times—18 st.

Rnd 4: [2 sc in next st, sc in next 2 st] 6 times—24 st.

Rnd 5: [2 sc in next st, sc in next 7 st] 3 times—27 st.

Rnds 6–8: (3 rounds) sc in each st around—27 st.

Rnd 9: [2 sc in next st, sc in next 8 st] 3 times—30 st.

Rnds 10–11: (2 rounds) sc in each st around—30 st. (Fig. C—page 31)

• Sl st in next st and FO, leaving a length of yarn.

• Sew onto the head around the edge of the hair and secure it in a few places. (Fig. D)

HAIR BUNS (make 2): Dark brown yarn.

Rnd 1: ch 2, work 6 sc into first ch—6 st.

Rnd 2: 2 sc in each sc around—12 sc.

Rnd 3: [2 sc in next st, sc in next st] 6 times—18 st.

Rnds 4–5: (2 rounds) sc in each st around—18 st.

Rnd 6: [sc2tog, sc in next st] 6 times—12 st.

Rnd 7: [sc2tog] 6 times—6 st. FO, leaving a length of yarn.

• Stuff slightly and sew shut. (Fig. E) Sew onto the sides of the head along rnd 6 of the buns, then sew loosely through the centers so the buns keep their shape. (Fig. F)

ARMS (make 2): Start with pale peach yarn.

Rnd 1: ch 2, work 6 sc into first ch—6 st.

Rnd 2: sc in each st around—6 st.

• Change to white yarn.

Rnd 3: [2 sc in next st, sc in next st] 3 times—9 st.

Rnds 4–6: (3 rounds) sc in each st around—9 st.

Rnd 7: sc2tog, sc in next 7 st—8 st.

Rnd 8: sc in each st around—8 st.

Rnd 9: [sc2tog, sc in next 2 st] 2 times—6 st.

• Sl st in next st and FO, leaving a length of yarn.

• Stuff just a little at the end of the arms if you want them to be firm (or don't stuff them at all). Then sew the arms to the body.

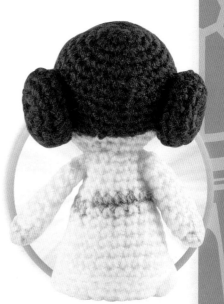

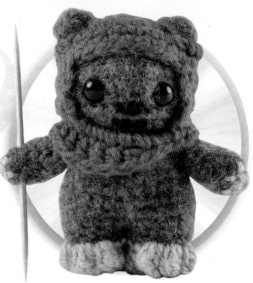

WICKET THE EWOK

FINISHED SIZE: approximately 3" tall

Brave and curious, Wicket befriends Princess Leia on the forest moon of Endor. Although small, Wicket and the other Ewoks lend a huge hand to help the Rebel Alliance attack the Imperial forces.

MATERIALS

- Brown yarn (approx. 0.7 oz/20 g)
- Rust-brown yarn (approx. 0.2 oz/5 g)
- Beige yarn (approx. 0.2 oz/5 g)
- Small amount of black yarn (for nose and mouth)
- E/4 (3.5 mm) hook
- Tapestry needle

- Pair of black plastic safety eyes (7.5 mm)
- Stuffing
- Stitch marker
- Wire pet brush (optional)
- Toothpick (optional, for his spear)

NOTE: *Try to find a yarn with some wool in it, as that will give a nice effect for the fur. If you want to make Wicket fuzzier, you can use a wire pet brush to brush the yarn—follow the instructions in the pattern for when you should brush. Do not brush too much, as Ewoks have short fur. I recommend that you crochet a test swatch with the yarn you have selected and brush it to check whether you like the effect.*

HEAD AND BODY: Brown yarn.

Rnd 1: ch 2, work 6 sc into first ch—6 st.

Rnd 2: 2 sc in each st around—12 st.

Rnd 3: [2 sc in next st, sc in next st] 6 times—18 st.

Rnd 4: [2 sc in next st, sc in next 2 st] 6 times—24 st.

Rnds 5–8: (4 rounds) sc in each st around—24 st.

Rnd 9: [sc2tog, sc in next 2 st] 6 times—18 st.

- If you are going to brush the yarn, do so now before the eyes are fitted or you will scratch them. Because you will not be able to see the rounds once the yarn is brushed, mark the correct place for the eyes (between rounds 6 and 7, 5 stitches apart) with a stitch marker first. (Fig. A–page 36)

- Fit eyes now, between rounds 6 and 7, 5 stitches apart, positioning the start of the rounds at the back of the head.

Rnd 10: [sc2tog, sc in next st] 6 times—12 st.

Rnd 11: [2 sc in next st, sc in next st] 6 times—18 st.

Rnd 12: [2 sc in next st, sc in next 5 st] 3 times—21 st.

Rnd 13: [2 sc in next st, sc in next 6 st] 3 times—24 st.

Rnd 14: sc in each st around—24 st.

Rnd 15: [2 sc in next st, sc in next 7 st] 3 times—27 st.

Rnds 16–17: (2 rounds) sc in each st around—27 st.

Rnd 18: [sc2tog, sc in next 7 st] 3 times—24 st.

Rnds 19–20: (2 rounds) sc in each st around—24 st. (Fig. B–page 36)

- Now lightly brush the rest of the body, if you wish.

To make the feet: Find the point between stitches in the previous round that is in the front-middle of Wicket. Then count back 5 stitches before that (not including the middle stitch) and mark this stitch.

- Change to beige yarn.

Rnd 21: sc in each sc around until you get to the marked stitch. Work a 3dc pop in each of next 3 st, sc in next 4 st, work a 3dc pop in each of next 3 st. Sc in each st around to the end of the round—24 st.

- Make sure the bobbles that make up the feet are pushed outward, and then firmly stuff the head and most of the body. Use black yarn to embroider a nose (3 lines of yarn) and mouth (2 lines of yarn). Finish stuffing, but don't stuff too firmly in the bottom third of his body.

Rnd 22: [sc2tog, sc in next 2 st] 6 times—18 st.

Rnd 23: [sc2tog, sc in next st] 6 times—12 st.

Rnd 24: [sc2tog] 6 times—6 st. FO.

- Thread about 12" of brown yarn

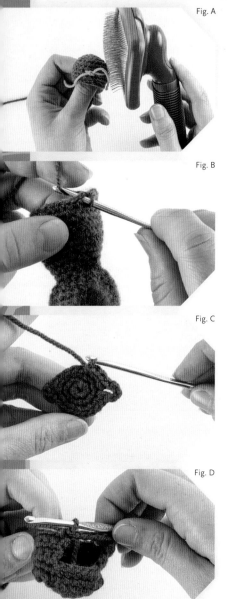

Fig. A

Fig. B

Fig. C

Fig. D

through to the front-middle of the body, 2 rows above the beige yarn of the feet. You will use this later to define the legs.

- Neatly sew up the hole at the base, and pull the yarn up through the body tightly to make sure the base lies flat. Take the yarn through the body a couple of times to secure the yarn before cutting it.

- To define the legs, take the brown yarn that you pulled through the front-middle of the body 2 rounds above the feet, pass it through the body to the same position at the back-middle, and pull tightly. Pull the yarn through to the front of the figure, one round lower, and again pull tightly. Continue to do this, working down the legs and feet round by round, until you reach the base of the figure. Take the yarn through the base (not tightly) a couple of times to secure the yarn before cutting it.

ARMS (make 2): Start with beige yarn.

Rnd 1: ch 2, work 6 sc into first ch—6 st.

- Change to brown yarn.

Rnd 2: [2 sc in next st, sc in next 2 st] 2 times—8 st.

Rnds 3–6: (4 rounds) sc in each st around—8 st.

Rnd 7: [sc2tog, sc in next 2 st] 2 times—6 st. Sl st in next st and FO, leaving a length of yarn.

- Brush the brown part of both arms lightly, if you wish, then sew them to the body without stuffing them.

EARS (make 2): Brown yarn.

Rnd 1: ch 2, work 8 sc into first ch—8 st.

Rnd 2: sc in each st around—8 st. Sl st in next st and FO, leaving a length of yarn.

• Brush both ears lightly, if you wish, and set aside.

HOOD: Rust-brown yarn.

Rnd 1: ch 2, work 6 sc into first ch—6 st.

Rnd 2: 2 sc in each st around—12 st.

Rnd 3: [2 sc in next st, sc in next st, 2 sc in next st, ch 4, sc in next st, 2 sc in next st, sc in next st] 2 times—18 st (not including the two ch 4 loops). (Fig. C)

Rnd 4: [sc in next 5 st, 3 sc around ch 4 loop, sc in next 4 st] 2 times—24 st.

Rnd 5: sc in each st around—24 st.

Rnd 6: sc in next 10 st, ch 1, turn.

Rows 7–9: sc in next 18 st, ch 1, turn.

Row 10: sc in next 18 st, ch 6.

Rnd 11: sc into first st of row 10 (Fig. D), sc in next 17 st, 6 sc over ch 6—24 st.

Rnd 12: sc in next 6 st, hdc in next st, dc in next 3 st, hdc in next 2 st, sc in next 4 st, hdc in next st, dc in next 3 st, hdc in next 2 st, sc in next ss in next st—24 st. FO and weave in end of yarn.

• Match the size and position of the ears with the ear holes in the hood. (Fig. E) Sew ears to Wicket's head, then put the hood on, ensuring that his ears stick through properly.

• If you wish to pose Wicket, simply push the toothpick carefully between the stitches in his hand. Do not give to a child with the stick.

Fig. E

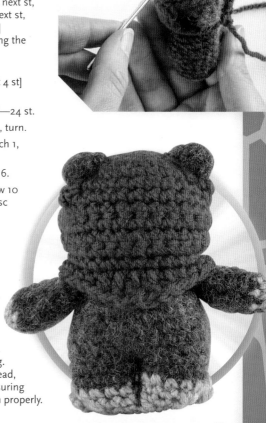

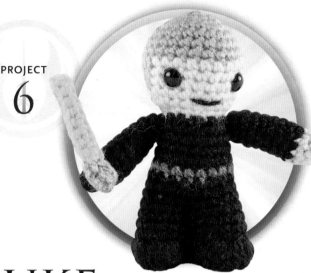

LUKE
SKYWALKER

FINISHED SIZE: approximately 3.5" tall

A farm boy raised on the remote planet of Tatooine, Luke is thrust into the middle of the Rebellion against the Galactic Empire. In the process, he discovers that his Force abilities and skill with a lightsaber rival those of the most feared man in the galaxy—his father.

MATERIALS

- Blond yarn (approx. 0.2 oz/5 g)
- Pale peach yarn (approx. 0.2 oz/5 g)
- Black yarn (approx. 0.7 oz/20 g)
- Small amount of dark gray yarn (for belt)
- Small amounts of silver-gray yarn and lime-green yarn (for lightsaber)

- E/4 (3.5 mm) hook
- Tapestry needle
- Pair of black plastic safety eyes (7.5 mm)
- Stuffing
- Stitch marker

HEAD AND BODY: Start with blond yarn.

Rnd 1: ch 2, work 6 sc into first ch—6 st.

Rnd 2: 2 sc in each st around—12 st.

Rnd 3: [2 sc in next st, sc in next st] 6 times—18 st.

Rnd 4: [2 sc in next st, sc in next 2 st] 6 times—24 st.

Rnds 5–7: (3 rounds) sc in each st around—24 st.

Rnd 8: *change to pale peach yarn,* sc in next 9 st, *change to blond yarn,* sc in next 15 st—24 st.

Rnd 9: *change to pale peach yarn,* sc in next 10 st, *change to blond yarn,* sc in next 14 st—24 st.

Rnd 10: *change to pale peach yarn,* sc in next 11 st, *change to blond yarn,* sc in next 12 st, *change to pale peach yarn,* sc in next st—24 st.

Rnd 11: sc in next 11 st, *change to blonde yarn,* sc in next 12 st, *change to pale peach yarn,* sc in next st—24 st.

Rnd 12: [sc2tog, sc in next 2 st] 6 times—18 st.

• Fit eyes now, between rounds 9 and 10, 6 stitches apart.

Rnd 13: [sc2tog, sc in next st] 6 times—12 st. (Fig. A)

• Change to black yarn.

Rnd 14: [2 sc in next st, sc in next st] 6 times—18 st.

Rnds 15–18: (4 rounds) sc in each st around—18 st.

• Stuff head now.

• Change to dark gray yarn.

Rnd 19: sc in each st around—18 st.

• Change to black yarn.

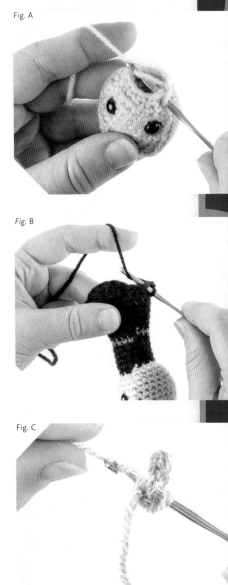

Fig. A

Fig. B

Fig. C

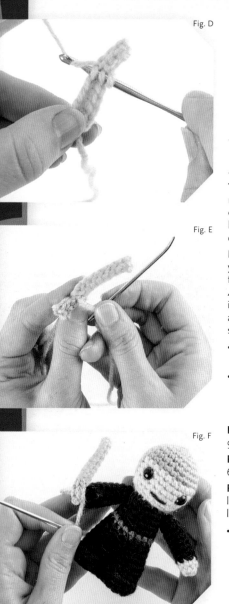

Fig. D

Fig. E

Fig. F

Rnd 20: [2 sc in next st, sc in next 5 st] 3 times—21 st.

Rnd 21: sc in each st around—21 st.

Rnd 22: [2 sc in next st, sc in next 6 st] 3 times—24 st.

Rnd 23: sc in each st around—24 st.

Rnd 24: [2 sc in next st, sc in next 7 st] 3 times—27 st.

Rnds 25–26: (2 rounds) sc in each st around—27 st.

To make the feet: Find the stitch in round 26 that is in the front-middle of Luke. Then count back 6 stitches before that (not including the middle stitch) and mark this stitch.

Rnd 27: sc in each st around until you get to the marked stitch. Make feet: Work a 3dc bob in each of next 4 st, sc in next 5 st, work a 3dc bob in each of next 4 st. Sc in each st around to the end of the round—27 st. (Fig. B–page 39)

• Make sure the bobbles that make up the feet are pushed outward.

• Finish stuffing head and stuff top half of body firmly; stuff slightly less firmly below the waist. Use black yarn to sew a small mouth.

Rnd 28: [sc2tog, sc in next st] 9 times—18 st.

Rnd 29: [sc2tog, sc in next st] 6 times—12 st.

Rnd 30: [sc2tog] 6 times—6 st. FO, leaving a piece of yarn about 24" long.

• Neatly sew up the hole at the base, and pull the yarn out at the front-middle of Luke, between rounds 22 and 23. Then pull the yarn up tightly to make sure the base lies flat.

• To define the legs, pass the yarn

through the body to the same position at the middle back and pull tightly. Next, pull the yarn back through the figure to the front, one round lower, and again pull tightly. Continue to do this, working down the legs round by round, until you reach the base of the figure. Take the yarn through the base (not tightly) a couple of times to secure the yarn before cutting it.

ARMS (make 2): *Start with pale peach yarn for left arm, black yarn for right arm.*

Rnd 1: ch 2, work 6 sc into first ch—6 st.

Rnd 2: sc in each st around—6 st.

• Change to or continue with black yarn.

Rnd 3: [2 sc in next st, sc in next 2 st] 2 times—8 st.

Rnds 4–9: (6 rounds) sc in each st around—8 st.

Rnd 10: [sc2tog, sc in next 2 st] 2 times—6 st. Sl st in next st, then FO, leaving a length of yarn.

• Stuff just a little in the end of the arms and sew them to the body, being sure to put the one with the black hand on Luke's right side.

LIGHTSABER:

• To make a lightsaber for Luke, you need to make two short lengths of cord.

• Using silver-gray yarn:
 • ch 4, skip ch next to hook and sl st in next 3 ch. Ch 1, turn.
 • sc in next 3 sl st, ch 1, turn.
 • sl st between back loop of each sc and the loops formed along the bottom to join edges together. FO. (Fig. C–page 39)

• Using lime-green yarn:
 • ch 9, skip ch next to hook and sl st in next 8 ch. Ch 1, turn.
 • sc in next 8 sl st, ch 1, turn.
 • sl st between back loop of each sc and the loops formed along the bottom to join edges together. FO. (Fig. D)

• Sew the ends of yarn through each part and use them to neaten each end, if necessary. Take the longest end of lime-green yarn and use it to sew the two parts together. (Fig. E)

• Use the longest end of silver-gray yarn to sew the lightsaber to Luke's right hand. It will be stiff enough to hold its shape if your figure is on display, but it will bend when played with. (Fig. F)

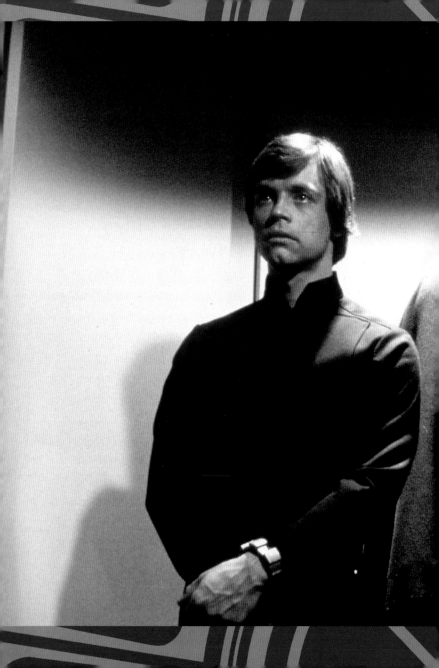

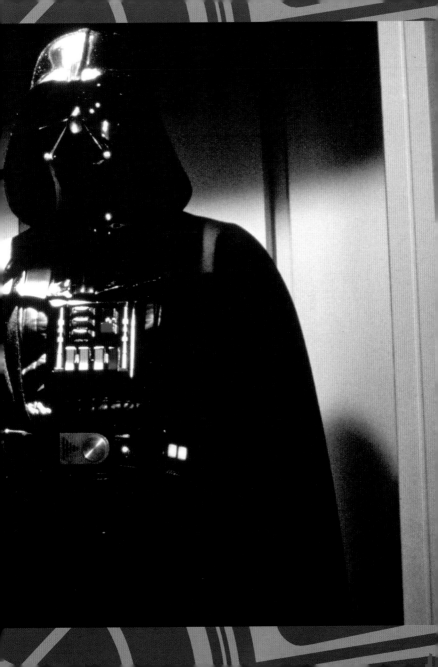

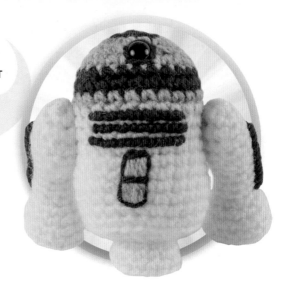

R2-D2

FINISHED SIZE: approximately 3" tall

Despite his limited style of communicating, this tough little astromech droid has a strong personality. A determined rebel, R2 is useful to have around in a tight spot.

MATERIALS

- White yarn (approx. 0.7 oz/20 g)
- Silver-gray yarn (approx. 0.2 oz/5 g)
- Blue yarn (approx. 0.2 oz/5 g)
- E/4 (3.5 mm) hook
- Tapestry needle

- 1 black plastic safety eye (7.5 mm)
- Pair of plastic safety eyes of any color (9 mm with a shank of approx. 12 mm)
- Stuffing
- Stitch marker

LEGS (make 2): White yarn.

Rnd 1: ch 2, work 6 sc into first ch—6 st.

Rnd 2: 2 sc in each st around—12 st.

Rnds 3–5: (3 rounds) sc in each st around—12 st.

Rnd 6: [sc2tog, sc2tog, sc in next 2 st] 2 times—8 st.

• Insert one of the 9 mm eyes on the inside of each leg with the shank sticking out between rounds 2 and 3—the decreases on round 6 will be at the back and front of the legs. (Fig. A–page 46)

Rnds 7–10: (4 rounds) sc in each st around—8 st.

Rnd 11: [2 sc in next st, sc in next st] 4 times—12 st.

Rnd 12: sc in each st around—12 st.

Rnd 13: sc in next st, [2 sc in next st, sc in next 2 st] 3 times, 2 sc in next st, sc in next st—16 st.

Rnd 14: sc in each st around—16 st.

Rnd 15: [in BLO, sc in next 2 st, sc2tog,] 4 times—12 st.

Rnd 16: [sc2tog] 6 times—6 st. FO, leaving a length of yarn.

• Using blue yarn, sew three vertical lines on the outside of each leg, between the bottom of the third round and the bottom of the 10th round.

• Stuff, not too firmly, and with the blue yarn sew over the three lines horizontally many times, ensuring you sew into the white of the leg a little each time. (Fig. B–page 46)

• Flatten the top of the leg, and neatly sew up the hole at the base, pulling the yarn up through the leg tightly to make sure the base lies flat.

BODY: Start with blue yarn.

Rnd 1: ch 2, work 6 sc into first ch—6 st.

Rnd 2: 2 sc in each st around—12 st.

• Change to silver-gray yarn.

Rnd 3: [2 sc in next st, sc in next st] 6 times—18 st.

Rnd 4: [2 sc in next st, sc in next 2 st] 6 times—24 st.

Rnd 5: sc in each st around—24 st.

• Change to blue yarn.

Rnds 6–7: (2 rounds) sc in each st around—24 st.

• Change to silver-gray yarn.

Rnd 8: sc in each st around—24 st.

• Fit 7.5 mm eye between rounds 4 and 5, positioning the start of the rounds at the back of the body.

• Change to white yarn.

Rnds 9–18: (10 rounds) sc in each st around—24 st.

To make body details:

• Using silver-gray yarn, sew four or five vertical lines over rounds 13 to 16 at the front-middle of the figure.

• Change to blue yarn and sew three horizontal lines across the front on each of the first three rounds of white, making sure you do not pull them tight. Sew over each line vertically many times to create a solid, thick line. (Fig. C–page 46)

• Still using the blue yarn, sew around the edges and across the middle of the gray patch, then sew a square around the eye.

• Now fix the legs firmly in place on either side of the body. Push the shanks of the safety eyes between

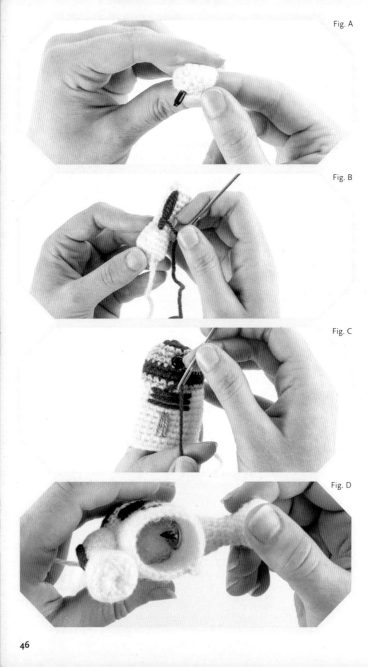

Fig. A

Fig. B

Fig. C

Fig. D

the 10th and 11th rounds and secure with washers. (Fig. D)

• Stuff firmly.

Rnd 19: [in BLO, sc2tog, sc in next st] 8 times—16 st.

Rnd 20: [sc2tog, sc in next 2 st] 4 times—12 st.

Rnd 21: [sc2tog, sc in next st] 4 times—8 st.

Rnd 22: [2 sc in next st, sc in next st] 4 times—12 st.

Rnd 23: [2 sc in next st, sc in next 2 st] 4 times—16 st.

Rnd 24: sc in each st around—16 st.

Rnd 25: [in BLO, sc2tog, sc in next 2 st] 4 times—12 st.

Rnd 26: [sc2tog] 6 times—6 st. FO, leaving length of yarn.

• Finish stuffing, then neatly sew up the hole at the base, pulling the yarn up through the body tightly to make sure the base lies flat. Take the yarn through the body a couple of times to secure the yarn before cutting it.

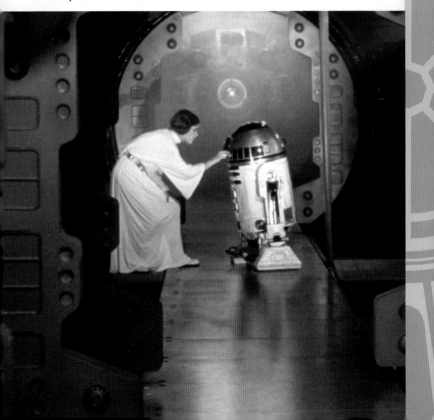

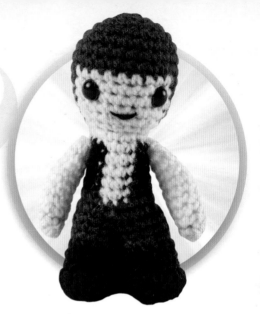

HAN SOLO

FINISHED SIZE: approximately 3.5" tall

A smuggler with a heart of gold, Han is pulled into the rebellion against his better judgment. As the pilot of the *Millennium Falcon*, he wins the love of Princess Leia and (almost) outsmarts Boba Fett.

MATERIALS

- Brown yarn (approx. 0.2 oz/5 g)
- Pale peach yarn (approx. 0.2 oz/5 g)
- Cream yarn (approx. 0.2 oz/5 g)
- Black yarn (approx. 0.2 oz/5 g)
- Dark blue yarn (approx. 0.2 oz/5 g)
- Small amount of dark red yarn (for trousers)

- E/4 (3.5 mm) hook
- Tapestry needle
- Pair of black plastic safety eyes (7.5 mm)
- Stuffing
- Stitch marker

HEAD AND BODY: Start with brown yarn.

Rnd 1: ch 2, work 6 sc into first ch—6 st.

Rnd 2: 2 sc in each st around—12 st.

Rnd 3: [2 sc in next st, sc in next st] 6 times—18 st.

Rnd 4: [2 sc in next st, sc in next 2 st] 6 times—24 st.

Rnds 5–7: (3 rounds) sc in each st around—24 st.

Rnd 8: *change to pale peach yarn,* sc in next 9 st, *change to brown yarn,* sc in next 15 st—24 st.

Rnd 9: *change to pale peach yarn,* sc in next 10 st, *change to brown yarn,* sc in next 14 st—24 st.

Rnd 10: *change to pale peach yarn,* sc in next 11 st, *change to brown yarn,* sc in next 12 st, *change to pale peach yarn,* sc in next st—24 st. (Fig. A–page 50)

Rnd 11: sc in next 11 st, *change to brown yarn,* sc in next 12 st, *change to pale peach yarn,* sc in next st—24 st.

Rnd 12: [sc2tog, sc in next 2 st] 6 times—18 st.

• Fit eyes now, between rounds 9 and 10, 6 stitches apart.

Rnd 13: [sc2tog, sc in next st] 6 times—12 st.

• Change to cream yarn.

Rnd 14: [sc in next st, 2 sc in next st] 6 times—18 st.

Rnd 15: *change to black yarn,* sc in next 3 st, *change to cream yarn,* sc in next 3 st, *change to black yarn,* sc in next 12 st—18 st.

Rnds 16–19: (4 rounds) *continue with black yarn,* sc in next 3 st, *change to cream yarn,* sc in next 3 st, *change to black yarn,* sc in next 12 st—18 st. (Fig. B–page 50)

• Stuff head now and, using 2 short lines, sew a small mouth with black yarn.

• Change to brown yarn.

Rnd 20: sc in each st around—18 st.

• Change to dark blue yarn.

Rnd 21: [sc in next 5 st, 2 sc in next st] 3 times—21 st.

Rnd 22: sc in each st around—21 st.

Rnd 23: [sc in next 6 st, 2 sc in next st] 3 times—24 st.

Rnd 24: sc in each st around—24 st.

• Change to black yarn.

Rnd 25: [sc in next 7 st, 2 sc in next st] 3 times—27 st.

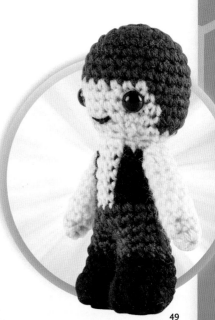

49

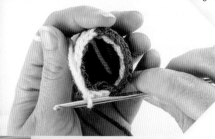

Fig. A

Rnds 26–27: (2 rounds) sc in each st around—27 st.

To make the feet: Find the stitch in round 27 that is in the front-middle of Han. Then count back 6 stitches before that (not including the middle stitch) and mark this stitch.

Rnd 28: sc in each st around until you get to the marked stitch. Work a 3dc bob in each of next 4 st, sc in next 5 st, work a 3dc bob in each of next 4 st. Sc in each st around to the end of the round—27 st.

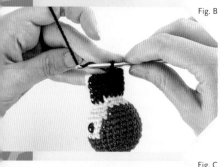

Fig. B

- Make sure the bobbles that make up the feet are pushed outward.
- Finish stuffing head and top half of body firmly; stuff slightly less firmly below the waist.

Rnd 29: [sc2tog, sc in next st] 9 times—18 st.

Rnd 30: [sc2tog, sc in next st] 6 times—12 st.

Rnd 31: [sc2tog] 6 times—6 st. FO, leaving a piece of yarn about 24" long.

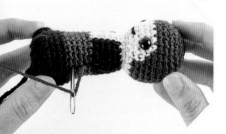

Fig. C

- Using dark red yarn, sew lines down the sides of Han's trousers. (Fig. C)
- Neatly sew up the hole at the base, and then pull the yarn out at the front-middle of Han, between the second and third rounds below his belt. Pull the yarn up tightly to make sure the base lies flat.

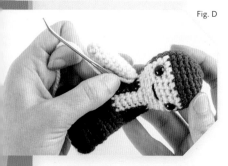

Fig. D

- To define the legs, pass the yarn through the body to the same position at the middle back and pull tightly. Next, pull the yarn through to the front of the figure, one round lower, and again pull tightly. Continue to do this, working down the legs round by round, until you

reach the base of the figure. Take the yarn through the base (not tightly) a couple of times to secure the yarn before cutting it.

ARMS (make 2): Start with pale peach yarn.

Rnd 1: ch 2, work 6 sc into first ch—6 st.

Rnd 2: sc in each st around—6 st.

• Change to cream yarn.

Rnd 3: [2 sc in next st, sc in next 2 st] 2 times—8 st.

Rnds 4–9: (6 rounds) sc in each st around—8 st.

Rnd 10: [sc2tog, sc in next 2 st] 2 times—6 st. Sl st in next st, then FO, leaving a length of yarn.

• Stuff the ends of the arms slightly, then sew the arms to the body. (Fig. D)

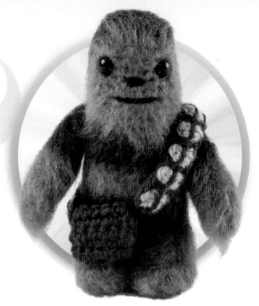

CHEWBACCA

FINISHED SIZE: approximately 4.5" tall

Han Solo's best friend and copilot, this imposing Wookiee is a clever mechanic and a fearsome fighter. But it is his loyalty to his friends that makes Chewbacca a formidable asset to the rebellion.

MATERIALS

- Dark brown yarn (approx. 0.5 oz/ 15 g)
- Light brown yarn (approx. 0.5 oz/15 g)
- Small amount of silver-gray yarn (for bandolier)
- Small amount of russet-brown yarn (for bag)
- Small amount of black yarn (for nose and mouth)

- E/4 (3.5 mm) hook
- Tapestry needle
- Pair of black plastic safety eyes (7.5 mm)
- Stuffing
- Stitch marker
- Wire pet brush

NOTE: *To create Chewbacca's fur use a wire pet brush to brush the yarn—follow the instructions in the pattern for when you should brush. I recommend you crochet a test swatch with the yarn you have selected and brush it to check whether you like the effect. You will need to brush quite vigorously in several directions to get the right furry effect.*

HEAD AND BODY: Start with dark brown yarn.

Rnd 1: ch 2, work 6 sc into first ch—6 st.

Rnd 2: 2 sc in each st around—12 st.

Rnd 3: [2 sc in next st, sc in next st] 6 times—18 st.

Rnd 4: [2 sc in next st, sc in next 5 st] 3 times—21 st.

Rnd 5: sc in next 4 st, *change to light brown yarn*, sc in next 5 st, *change to dark brown yarn*, sc in next 12 st —21 st.

Rnd 6: sc in next 2 st, *change to light brown yarn*, sc in next 9 st, *change to dark brown yarn*, sc in next 10 st —21 st.

Rnd 7: sc in next 2 st, *change to light brown yarn*, sc in next 10 st, *change to dark brown yarn*, sc in next 9 st —21 st.

Rnd 8: 2 sc in next st, sc in next st, *change to light brown yarn*, sc in next 5 st, 2 sc in next st, sc in next 5 st, *change to dark brown yarn*, sc in next st, 2 sc in next st, sc in next 6 st—24 st.

Rnd 9: sc in next 3 st, *change to light brown yarn*, sc in next 12 st, *change to dark brown yarn*, sc in next 9 st —24 st.

Fig. A

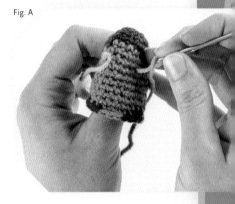

Fig. B

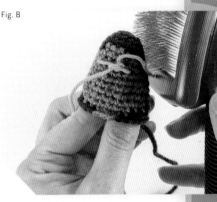

Fig. C

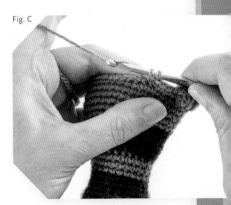

Rnds 10–11: (2 rounds) sc in next 3 st, *change to light brown yarn*, sc in next 13 st, *change to dark brown yarn*, sc in next 8 st —24 st.

Rnd 12: sc in next 4 st, *change to light brown yarn*, sc in next 11 st, *change to dark brown yarn*, sc in next 9 st —24 st.

Rnd 13: sc in next 6 st, *change to light brown yarn*, sc in next 7 st, *change to dark brown yarn*, sc in next 11 st —24 st.

Rnd 14: sc in next 9 st, *change to light brown yarn*, sc in next 3 st, *change to dark brown yarn*, sc in next 12 st—24 st.

• Brush the yarn now before the eyes are fitted or you will scratch them. Because you will not be able to see the rounds once the yarn is brushed, mark the correct place for the eyes (between rounds 7 and 8) with a stitch marker first. Brush away from the face area and over the top of Chewbacca's head. (Figs. A & B–page 53)

• Fit the eyes between rounds 7 and 8, 5 stitches apart, with the light brown section at the front.

• Continue with dark brown yarn.

Rnds 15–17: (3 rounds) sc in each st around—24 st.

• Stuff the head and use the black yarn to embroider a nose (four lines of yarn) and a mouth.

• Change to light brown yarn.

Rnds 18–20: (3 rounds) sc in each st around—24 st.

• Change to dark brown yarn.

Rnd 21: [2 sc in next st, sc in next 7 st] 3 times—27 st.

Rnds 22–25: (4 rounds) sc in each st around—27 st.

Rnd 26: [2 sc in next st, sc in next 8 st] 3 times—30 st.

• Change to light brown yarn.

Rnds 27–28: (2 rounds) sc in each st around—30 st.

Rnd 29: [2 sc in next st, sc in next 9 st] 3 times—33 st.

Rnds 30–31: (2 rounds) sc in each st around—33 st.

To make the feet: Find the stitch in the previous round that is in the front-middle of Chewbacca. Then count back 6 stitches before that (not including the middle stitch) and mark this stitch.

• Change to dark brown yarn.

Rnd 32: sc in each st around until you get to the marked stitch. Work a 3dc bob in each of next 4 st, sc in next 5 st, work a 3dc bob in each of next 4 st. Sc in each st around to the end of the round—33 st. (Fig. C–page 53)

• Make sure the bobbles that make up the feet are pushed outward.

• Finish stuffing head and top half of body firmly; stuff slightly less firmly below the waist.

Rnd 33: [sc2tog, sc in next 9 st] 3 times—30 st.

Rnd 34: [sc2tog, sc in next 3 st] 6 times—24 st.

Rnd 35: [sc2tog] 6 times—12 st.

Rnd 36: [sc2tog] 6 times—6 st. FO, leaving a piece of yarn about 24" long.

• Neatly sew up the hole at the base, then brush the rest of the body a little, but not so much that you

can't see the rounds. Pull the yarn out at the front-middle of Chewbacca, 8 rounds up from his feet. Pull the yarn up tightly to make sure the base lies flat.

- To define the legs, pass the yarn through the body to the same position at the middle back and pull tightly. Next pull the yarn through to the front of the figure, one round lower, and again pull tightly. Continue to do this, working down the legs round by round, until you reach the base of the figure. Take the yarn through the base (not tightly) a couple of times to secure the yarn before cutting it.

- Finish by brushing Chewbacca so that he is nice and furry, ending by brushing downwards. You may need to trim the fur on his feet.

ARMS (make 2): *Start with light brown yarn.*

Rnd 1: ch 2, work 6 sc into first ch—6 st.

Rnd 2: [2 sc in next st, sc in next 2 st] 2 times—8 st.

Rnd 3: [2 sc in next st, sc in next 3 st] 2 times—10 st.

Rnds 4–8: (5 rounds) sc in each st around—10 st.

- Change to dark brown yarn.

Rnd 9: sc in each st around—10 st.

Rnd 10: [sc2tog, sc in next 3 st] 2 times—8 st.

Rnds 11–13: (3 rounds) sc in each st around—8 st.

Rnd 14: [sc2tog, sc in next 2 st] 2 times—6 st. Sl st in next st then FO, leaving a length of yarn.

Fig. D

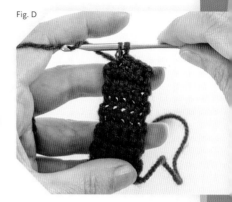

Fig. E

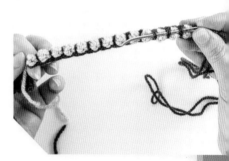

Fig. F

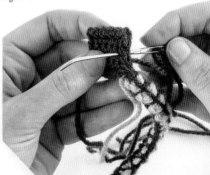

• Brush both arms until furry. Stuff lightly, then sew them to the body.

BAG AND BANDOLIER:

Start with russet-brown yarn.

• Ch 6.

Row 1: sc in second ch from hook, sc in next 4 ch, ch 1, turn—5 st.

Rows 2–11: sc in next 5 st, ch 1, turn—5 st.

Row 12: sc in next 5 st—5 st. (Fig. D–page 55)

• Ch 28, sc in second ch from hook

To make the strap: *Change to silver-gray yarn (carry russet-brown yarn under the silver-gray yarn),* [2dc bob in next ch, sc in next ch] repeat until there are only 2 ch left. 2dc bob in

next ch, *change to russet-brown yarn,* sc in next ch, ch 1, turn.

• Skip first sc, sl st in 2dc bob [spike sc in next sc, sl st in next 2dc bob] repeat until last sc, sl st in last st.

• FO, leaving length of yarn at least 24" long.

• Sew a line of yarn along the strap, over the silver-gray bobbles and under the spike stitches. (Fig. E–page 55)

• Fold the bag over so it has a flap of 3 rows. Sew the edges of the bag together using the length of yarn, and then sew the flap shut. (Fig. F–page 55)

• Sew the loose end of the strap to the other side of the bag. Secure the end of the yarn and cut.

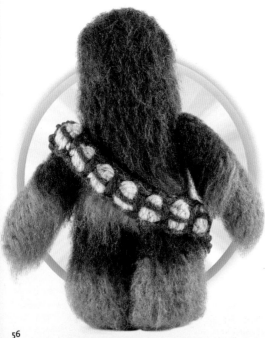

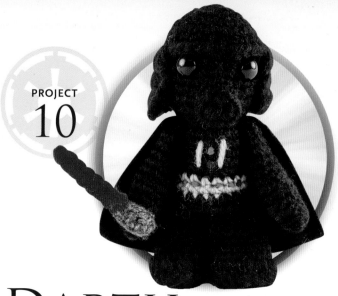

DARTH VADER

FINISHED SIZE: approximately 4" tall

More machine than man, Vader's menacing figure is a symbol of power and fear in the Empire. He is a powerful Sith Lord, obedient to the Emperor until his humanity is reawakened by the appearance of his son, Luke.

MATERIALS

- Black yarn (approx. 1 oz/30 g)
- Small amount of silver-gray yarn (for armor details)
- Small amounts of bright red yarn and green yarn (for armor details)
- Small amounts of dark gray yarn and bright red yarn (for lightsaber)
- E/4 (3.5 mm) hook
- Tapestry needle
- Piece of black felt, 4" x 2.5" (10 cm x 6 cm)
- Pair of black plastic safety eyes (9 mm)
- Stuffing
- Stitch marker

HEAD AND BODY: Black yarn.

Rnd 1: ch 2, work 6 sc into first ch—6 st.

Rnd 2: 2 sc in each st around—12 st.

Rnd 3: [2 sc in next st, sc in next st] 6 times—18 st.

Rnd 4: [2 sc in next st, sc in next 2 st] 6 times—24 st.

Rnds 5–6: (2 rounds) sc in each st around—24 st.

Rnd 7a: *(leave the marker at the start of this round)* [in FLO, 2 sc in next st, sc in next 3 st] 6 times—30 st. (Fig. A)

NOTE: *Rounds 7a and 7b are both worked into round 6, which has 24 stitches. So, when you do 7a in the front loops, you increase to 30 st, then carry on and do the back of the helmet. Then you go back and work into the back loops of round 6 and do round 7b with no increases (and carry on with the bottom half of the head).*

To make the helmet: Ch 1, turn.

Row 1: sc in next 20 st, ch 1, turn—20 st.

Row 2: sc in next 20 st, ch 1, turn—20 st.

Row 3: [sc in next 4 st, 2 sc in next st] 3 times, sc in next 5 st, ch 1, turn—23 st.

Rows 4–5: (2 rows) sc in next 23 st, ch 1, turn—23 st.

Row 6: skip first st, sc in next 21 st, sl st in next st. FO, leaving a length of yarn.

• You will now continue with the head by working into the back loops left over from round 6.

Fig. A

Fig. B

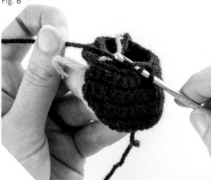

Fig. C

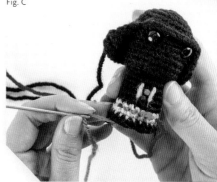

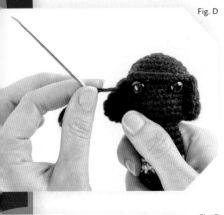

Fig. D

Join yarn into the first back loop where you left the marker. Bend the helmet back to make it easier to work on the head. (Fig. B–page 59)

Rnd 7b: in BLO, sc in each st around—24 st.

Rnds 8–13: (6 rounds) sc in each st around—24 st.

• Fit the eyes between rounds 8 and 9, 5 stitches apart.

Rnd 14: [sc2tog] 12 times—12 st.

Rnd 15: [2 sc in next st, sc in next st] 6 times—18 st.

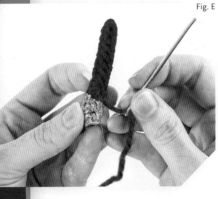

Fig. E

Rnds 16–20: (5 rounds) sc in each st around—18 st.

• Stuff head now.

• Change to silver-gray yarn.

Rnds 21–22: (2 rounds) sc in each st around—18 st.

• Change to black yarn, leaving a length of silver-gray yarn for sewing details.

Rnd 23: [2 sc in next st, sc in next 5 st] 3 times—21 st.

• Use silver-gray yarn to sew two lines on Vader's chest.

• Use red and green yarn to add buttons on Vader's belt and chest by sewing a couple of stitches in the appropriate place for each one. See the photo (Fig. C–page 59) for the positions.

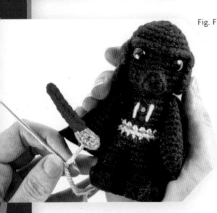

Fig. F

• Continue with black yarn.

Rnd 24: sc in each st around—21 st.

Rnd 25: [2 sc in next st, sc in next 6 st] 3 times—24 st.

Rnd 26: sc in each st around—24 st.

Rnd 27: [2 sc in next st, sc in next 7 st] 3 times—27 st.

Rnd 28: sc in each st around—27 st.

Rnd 29: [2 sc in next st, sc in next 8 st] 3 times—30 st.

Rnd 30: sc in each st around—30 st.

To make the feet: Find the stitch in round 30 that is in the front-middle of Vader. Then count back 7 stitches before that (not including the middle stitch) and mark this stitch.

Rnd 31: sc in each st around until you get to the marked stitch. Work a 3dc bob in each of next 4 st, sc in next 7 st, work a 3dc bob in each of next 4 st. Sc in each st around to the end of the round—30 st.

• Make sure the bobbles that make up the feet are pushed outward.

• Finish stuffing head and top half of body firmly; stuff slightly less firmly below the waist.

Rnd 32: [sc2tog, sc in next st] 10 times—20 st.

Rnd 33: [sc2tog, sc in next 2 st] 5 times—15 st.

Rnd 34: [sc2tog, sc in next st] 5 times—10 st.

Rnd 35: [sc2tog] 5 times—5 st. FO, leaving a piece of yarn about 24" long.

• Neatly sew up the hole at the base, and pull the yarn out at the front-middle of Vader, 3 or 4 rounds below his belt. Then pull the yarn up tightly to make sure the base lies flat.

• To define the legs, pass the yarn through the body to the same position at the middle back and pull tightly. Pull the yarn through to the front of the figure, one round lower, and again pull tightly. Continue to do this, working down the legs round by round, until you

reach the base of the figure. Take the yarn through the base (not tightly) a couple of times to secure the yarn before cutting it.

FACE MASK: Black yarn.

Rnd 1: ch 2, work [2 sc, 1 dc] 3 times into first ch, join to first sc with sl st—9 st.

Rnd 2: in BLO, sc in each st around—9 st.

• Sl st into next st, FO, leaving a length of yarn.

• Use the length of yarn attached to the helmet to sew the edge of the helmet to the head. Make a couple of stitches on each side about halfway up, then do a couple more stitches over the middle of the brow to define it. (Fig. D)

• Sew on the face mask.

ARMS (make 2): Black yarn.

Rnd 1: ch 2, work 6 sc into first ch—6 st.

Rnd 2: sc in each st around—6 st.

Rnd 3: [2 sc in next st, sc in next st] 3 times—9 st.

Rnds 4–11: (8 rounds) sc in each st around—9 st.

Rnd 12: [sc2tog, sc in next st] 3 times—6 st. Sl st in next st, FO, leaving a length of yarn.

• Stuff lightly and sew the arms to the body, leaving the yarn from one of them to sew the cloak on.

• To make the cloak, use a piece of black felt, 4" x 2.5" (10 cm x 6 cm).

• Trace the pattern (page 62) onto thin paper, cut out the cloak shape, and pin the pattern to the felt. Cut

the felt, using the paper as your guide. Sew the cloak to Vader using a couple of stitches just above the arms on each side.

LIGHTSABER:

- To make a lightsaber for Darth Vader, you need to make two short lengths of cord.
- Using dark gray yarn:
 - ch 4, skip ch next to hook and sl st in next 3 ch. Ch 1, turn.
 - sc in next 3 st, ch 1, turn.
 - sl st between back loop of each sc and the loops formed along the bottom to join edges together. FO.
- Using bright red yarn:
 - ch 9, skip ch next to hook and sl st in next 8 ch. Ch 1, turn.

- sc in next 8 sl st, ch 1, turn.
- sl st between back loop of each sc and the loops formed along the bottom to join edges together. FO.
- Sew the ends of yarn through each part and use them to neaten each end, if necessary. Take the longest end of red yarn and use it to sew the two parts together. (Fig. E–page 60)
- Use the longest end of dark gray yarn to sew the lightsaber to Vader's right hand. It will be stiff enough to hold its shape if your figure is on display, but it will bend if played with. (Fig. F–page 60)

VADER CLOAK TEMPLATE

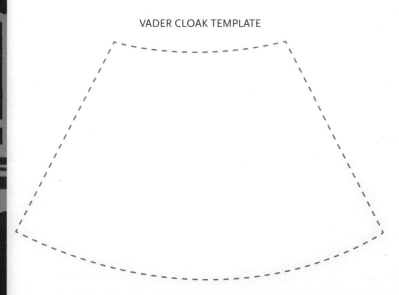

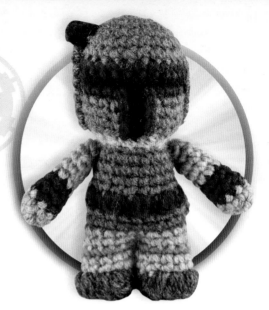

BOBA FETT

FINISHED SIZE: approximately 3.5" tall

Boba Fett's face is always hidden behind his iconic helmet, but his reputation as a bounty hunter is known far and wide. Employed by Darth Vader to track the rebels, he pursues and captures Han Solo—only to freeze him in carbonite and turn him over to Jabba the Hutt.

MATERIALS

- Sage-green yarn (approx. 0.4 oz/ 10 g)

- Silver-gray yarn (approx. 0.4 oz/10 g)

- Dark red yarn (approx. 0.2 oz/5 g)

- Dark gray yarn (approx. 0.2 oz/5 g)

- Small amount of black yarn (for helmet and rangefinder)

- Small amount of dark yellow yarn (for shoulders and knees)

- Small amount of russet-brown yarn (for belt)

- E/4 (3.5 mm) hook

- Tapestry needle

- Stuffing

- Stitch marker

HEAD AND BODY: Start with sage-green yarn.

Rnd 1: ch 2, work 6 sc into first ch—6 st.

Rnd 2: 2 sc in each st around—12 st.

Rnd 3: [2 sc in next st, sc in next st] 6 times—18 st.

Rnd 4: [2 sc in next st, sc in next 2 st] 6 times—24 st.

Rnds 5–6: (2 rounds) sc in each st around—24 st.

• Change to dark red yarn.

Rnd 7: sc in each st around—24 st.

• Change to sage-green yarn.

Rnd 8: sc in next 6 st, *change to dark red yarn,* sc in next st, *change to black yarn,* sc in next 10 st, *change to dark red yarn,* sc in next st, *change to sage-green yarn,* sc in next 6 st—24 st.

Rnd 9: sc in next 6 st, *change to dark red yarn,* sc in next 5 st, *change to black yarn,* sc in next 2 st, *change to dark red yarn,* sc in next 5 st, *change to sage-green yarn,* sc in next 6 st—24 st.

• Cut the dark red yarn, leaving about 24".

Rnd 10: sc in next 11 st, *change to black yarn,* sc in next 2 st, *change to sage-green yarn,* sc in next 11 st—24 st.

Rnd 11: sc in next 2 st, 2 sc in next st, [sc in next 3 st, 2 sc in next st] 2 times, *change to black yarn,* sc in next 2 st, *change to sage-green yarn,* sc in next 2 st, 2 sc in next st, [sc in next 3 st, 2 sc in next st] 2 times—30 st.

Rnd 12: sc in next 14 st, *change to black yarn,* sc in next 2 st, *change to sage-green yarn,* sc in next 14 st—30 st.

• Change to silver-gray yarn.

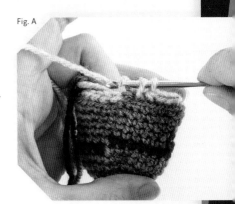

Fig. A

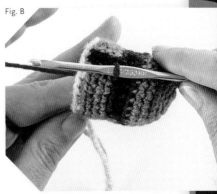

Fig. B

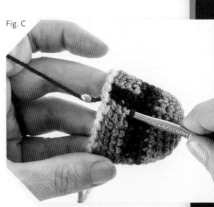

Fig. C

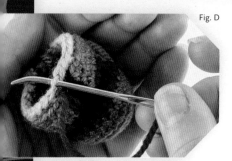

Fig. D

Rnd 13: in BLO, sc in next st, [sc2tog, sc in next 3 st] 5 times, sc2tog, sc in next 2 st—24 st. (Fig. A—page 65)

- To make the vertical red lines on either side of the vertical black segment on the helmet, use the 24" of dark red yarn you cut earlier. Secure your current loop with a stitch marker so your work doesn't come undone.

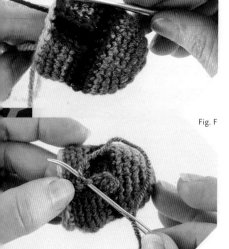

Fig. E

- To work a sl st along the surface, insert your hook into bottom of rnd 8 and pull a loop of the red yarn (on top-right of the black segment) from underneath through the fabric to the front of the helmet. (Fig. B—page 65)

- Push the hook into the next round down and pull a loop of red yarn through the hole and through the previous loop, making a sl st. (Fig. C—page 65)

Fig. F

- Do this four more times to make 5 sl st. Each sl st goes over one round; the last one goes over round 12. Pull the end of the yarn through the last loop as shown. (Fig. D)

- Thread the yarn onto your needle and insert through the bottom of the last st to the inside of the helmet. Secure the yarn on the inside, but do not cut.

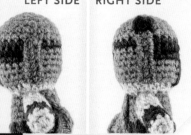

Fig. G

LEFT SIDE **RIGHT SIDE**

- Push the hook through the helmet at the top left of the black segment, and pull a loop of the red yarn through. Repeat the sl st process, working 5 sl st on the other side of the vertical black segment. Secure as before and cut the red yarn. (Fig. E)

- Pick up the last st in the silver-gray yarn and continue crocheting the rest of the body.

Rnd 14: [sc2tog] 12 times—12 st.

• Change to sage-green yarn.

Rnd 15: [2 sc in next st, sc in next st] 6 times—18 st.

Rnds 16–19: (4 rounds) sc in each st around—18 st.

• Stuff head now.

• Change to russet-brown yarn.

Rnd 20: [2dc bob in next st, sc in next st] 9 times—18 st.

Push bobbles outward.

• Change to sage-green yarn.

Rnd 21: [2 sc in next st, sc in next 5 st] 3 times—21 st.

Rnd 22: sc in each st around—21 st.

• Change to silver-gray yarn.

Rnd 23: [2 sc in next st, sc in next 6 st] 3 times—24 st.

Rnd 24: sc in each st around—24 st.

• Change to dark yellow yarn.

Rnd 25: [2 sc in next st, sc in next 7 st] 3 times—27 st.

• Change to silver-gray yarn.

Rnds 26–27: (2 rounds) sc in each st around—27 st.

• Cut silver-gray yarn, leaving a length of about 24". Thread this length of yarn out at the front-middle of Boba Fett's body, at the top of round 23.

• Change to dark gray yarn.

To make the feet: Find the stitch in round 27 that is in the front-middle of Boba Fett. Then count back 6 stitches before that (not including the middle stitch) and mark this stitch.

Rnd 28: sc in each st around until you get to the marked st. Make feet: Work a 3dc bob in each of next 4 st, sc in next 5 st, work a 3dc bob in each of next 4 st. Sc in each st around to the end of the round—27 st.

• Push the bobbles that make up the feet from the inside so that they stick out. Finish stuffing head and stuff top half of body firmly; stuff slightly less firmly below the waist.

Rnd 29: [sc2tog, sc in next st] 9 times—18 st.

Rnd 30: [sc2tog, sc in next st] 6 times—12 st.

Rnd 31: [sc2tog] 6 times—6 st. FO, leaving a length of yarn.

Fig. H

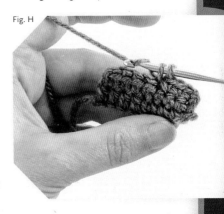

Fig. I

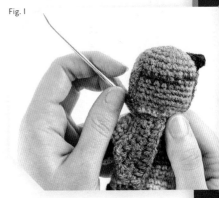

- Finish stuffing, using the length of dark gray yarn, and neatly sew up the hole at the base of the figure. Pull the yarn up tightly to make sure the base lies flat. Take the yarn through the body again (not tightly) and then cut it.

- To define the legs, take the silver-gray yarn sticking out at the front-middle, sew through the body from the top of round 24 to the top of round 23 at the middle-back, and pull tightly. Move down one round, then sew the yarn back through to the front of the figure and again pull tightly. Continue to do this, working down the legs round by round, until you reach the base of the figure. Take the yarn through the base (not tightly) a couple of times to secure the yarn before cutting it.

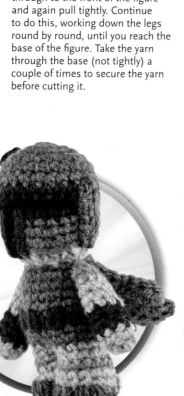

ARMS (make 2): Start with silver-gray yarn.

Rnd 1: ch 2, work 6 sc into first ch—6 st.

Rnd 2: [2 sc in next st, sc in next 2 st] 2 times—8 st.

- Change to dark red yarn.

Rnds 3–5: (3 rounds) sc in each st around—8 st.

- Change to silver-gray yarn.

Rnds 6–8: (3 rounds) sc in each st around—8 st.

- Change to dark yellow yarn.

Rnd 9: sc in each st around—8 st.

Rnd 10: [sc2tog, sc in next 2 st] 2 times—6 st. Sl st in next st, FO, leaving a length of yarn.

- Stuff very slightly and sew the arms to the body.

NOTE: *The details on either side of Boba Fett's helmet are made separately and sewn on. When you work into the chain for these parts, work into the back bump for the best effect. The sides of the helmet refer to Boba's left and right side, rather than the crocheter's.*

LEFT SIDE OF HELMET: Dark gray yarn.

- Ch 6, sc in second ch from hook, sc in next 4 ch. FO, leaving a length of yarn, and sew onto left side of head. Weave in loose ends. (Figs. F and G—page 66)

RIGHT SIDE OF HELMET: Dark gray yarn.

- Ch 7, sc in second ch from hook, sc in next 5 ch. FO, leaving a length of yarn, and sew onto right side of helmet. Weave in loose ends. (Fig. G—page 66)

TOP OF RANGEFINDER (triangular black lump on right side): Black yarn.

- Ch 5, sc in second ch from hook, sc in next 3 ch. FO, leaving a length of yarn. (Fig. G–page 66) Fold in half lengthwise and sew onto right side of head with the folded edge on the outside above the dark gray section. Weave in loose ends.

CLOAK: Sage-green yarn.

- Ch 9.

Row 1: sc in second ch from hook, sc in next 3 ch, hdc in next 4 ch, ch 2, turn—8 st.

Row 2: hdc in next 4 st, sc in next 4 st, ch 1, turn—8 st.

Row 3: sc in next 4 st, hdc in next 3 st—7 st. (Fig. H–page 67)

- FO, leaving a length of yarn. Take that yarn through the cloak to the narrower top and sew the cloak onto Boba Fett's left shoulder with the shorter edge nearest the arm. Weave in loose ends. (Fig. I–page 67)

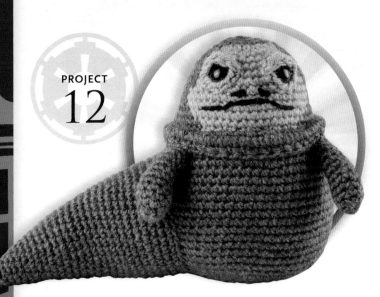

JABBA THE HUTT

FINISHED SIZE: approximately 4.5" tall and 6.5" long

Immense both in size and in the reach of his criminal empire, Jabba the Hutt is highly intelligent and utterly relentless. He doesn't accept failure, and he enjoys watching his victims suffer.

MATERIALS

- Green yarn (approx. 1.2 oz/35 g)
- Straw-colored yarn (approx. 0.2 oz/5 g)
- Small amount of black yarn (for nose and mouth)
- E/4 (3.5 mm) hook
- Tapestry needle
- Pair of amber plastic safety eyes (12 mm)
- Stuffing
- Stitch marker

EYELIDS (make 2): Straw-colored yarn.

• Ch 11, skip ch next to hook, sc in next ch, hdc in next 2 ch, sl st in next ch, FO, leaving length of yarn. (Fig. A)

HEAD AND BODY: Start with green yarn.

Rnd 1: ch 2, work 6 sc into first ch—6 st.

Rnd 2: 2 sc in each st around—12 st.

Rnd 3: [2 sc in next st, sc in next st] 6 times—18 st.

Rnd 4: [2 sc in next st, sc in next 2 st] 2 times, *change to straw-colored yarn* [2 sc in next st, sc in next 2 st] 2 times, *change to green yarn* [2 sc in next st, sc in next 2 st] 2 times—24 st.

Rnd 5: [2 sc in next st, sc in next 3 st] 2 times, *change to straw-colored yarn* [2 sc in next st, sc in next 3 st] 2 times, sc in next st, *change to green yarn* sc in same st, sc in next 3 st, 2 sc in next st, sc in next 3 st—30 st.

Rnd 6: [2 sc in next st, sc in next 4 st] 2 times, sc in next st, *change to straw-colored yarn* sc in same st, sc in next 4 st, 2 sc in next st, sc in next 4 st, 2 sc in next st, *change to green yarn* sc in next 4 st, 2 sc in next st, sc in next 4 st—36 st.

Rnd 7: 2 sc in next st, sc in next 8 st, 2 sc in next st, sc in next 3 st, *change to straw-colored yarn* sc in next 5 st, 2 sc in next st, sc in next 7 st, *change to green yarn* sc in next st, 2 sc in next st, sc in next 8 st—40 st.

Rnd 8: 2 sc in next st, sc in next 9 st, 2 sc in next st, sc in next 4 st, *change to straw-colored yarn* sc in next 5 st, 2 sc in next st, sc in next 9 st, *change to green yarn* 2 sc in next st, sc in next 9 st—44 st.

Fig. A

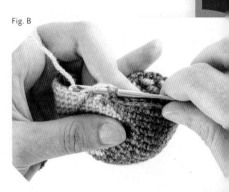

Fig. B

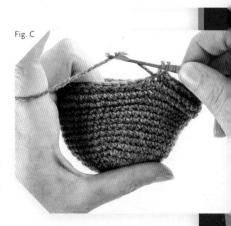

Fig. C

Rnd 9: sc in next 2 st, 2 sc in next st, sc in next 14 st, *change to straw-colored yarn* sc in next 7 st, 2 sc in next st, sc in next 9 st, *change to green yarn* sc in next 10 st—46 st.

Rnds 10–11: (2 rounds) sc in next 17 st, *change to straw-colored yarn* sc in next 20 st, *change to green yarn* sc in next 9 st—46 st.

Rnd 12: sc in next 18 st, *change to straw-colored yarn* sc in next 19 st, *change to green yarn* sc in next 9 st—46 st.

Rnd 13: sc in next 15 st, 2 sc in next st, sc in next 3 st, *change to straw-colored yarn* sc in next 17 st, *change to green yarn* sc in next 3 st, 2 sc in next st, sc in next 6 st—48 st.

Rnd 14: sc in next 22 st, *change to straw-colored yarn* sc in next 14 st, *change to green yarn* sc in next 12 st—48 st.

Rnd 15: sc in next 22 st, *change to straw-colored yarn* [sc2tog, sc in next st] 4 times, sc2tog, *change to green yarn* sc in next 12 st—43 st. (Fig. B–page 71)

• Continue with green yarn only.

Rnd 16: in FLO [2 sc in next st, sc in next st] 11 times, [2 sc in next st] 9 times, [2 sc in next st, sc in next st] 6 times—69 st.

Rnd 17: sc in each st around—69 st.

Rnd 18: [sc2tog, sc in next st] 11 times, sc2tog 9 times, [sc2tog, sc in next st] 6 times—43 st. (Fig. C–page 71)

• Sl st in next st and FO, leaving a length of yarn.

• Fit eyes between rounds 8 and 9, 9 stitches apart. (Fig. D)

• To continue with the body, fold back rounds 16–18 and join in yarn to the first back loop left from round 15. (To join the yarn, put your hook through the back loop and pull the new yarn through. YO and pull through the loop on the hook. Tighten. Start rnd 19 in the same stitch.)

Rnd 19: in BLO, sc in next 42 st, 2 sc in next st—44 st.

Rnd 20: [2 sc in next st, sc in next 10 st] 4 times—48 st.

Rnd 21: [2 sc in next st, sc in next 7 st] 6 times—54 st.

Rnd 22: [2 sc in next st, sc in next 8 st] 6 times—60 st.

Rnds 23–35: (13 rounds) sc in each st around—60 st.

Rnd 36: [sc2tog, sc in next 8 st] 6 times—54 st.

Rnd 37: [sc2tog, sc in next 7 st] 6 times—48 st.

Rnd 38: [sc2tog, sc in next 6 st] 6 times—42 st.

• Start to stuff head and body and continue stuffing as you go along.

NOTE: *When stuffing a larger piece like this, you will need to add small amounts of stuffing at a time and push it in quite hard. Keep pushing it in as you add more, and make sure that the head is as well-stuffed as the body.*

Rnd 39: [sc2tog, sc in next 5 st] 6 times—36 st.

Rnd 40: [sc2tog, sc in next 4 st] 6 times—30 st.

Rnd 41: [sc2tog, sc in next 3 st] 6 times—24 st.

Rnd 42: [sc2tog, sc in next 2 st] 6 times—18 st.

Rnd 43: [sc2tog, sc in next st] 6 times—12 st.

Rnd 44: sc2tog 6 times—6 st.

- FO, leaving a length of yarn. Finish stuffing, then sew shut the hole at bottom, pulling the yarn up through the body to make the bottom flat.

- Sew eyelids around the eyes, with the larger part above the eye and the chain underneath. (Fig. E)

- Using black yarn, sew the nostrils and mouth (take the yarn in under the roll of flesh around the neck to hide the knot).

TAIL: Green yarn.

Rnd 1: ch 2, work 6 sc into first ch—6 st.

Rnd 2: sc in each st around—6 st.

Rnd 3: [2 sc in next st, sc in next st] 3 times—9 st.

Rnd 4: sc in each st around—9 st.

Rnd 5: [2 sc in next st, sc in next 2 st] 3 times—12 st.

Rnd 6: sc in each st around—12 st.

Rnd 7: [2 sc in next st, sc in next 3 st] 3 times—15 st.

Rnd 8: sc in each st around—15 st.

Rnd 9: [2 sc in next st, sc in next 4 st] 3 times—18 st.

Rnd 10: sc in each st around—18 st.

Rnd 11: [2 sc in next st, sc in next 5 st] 3 times—21 st.

Rnd 12: sc in each st around—21 st.

Rnd 13: [2 sc in next st, sc in next 6 st] 3 times—24 st.

Rnd 14: sc in each st around—24 st.

Fig. D

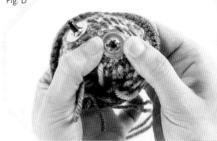

Fig. E

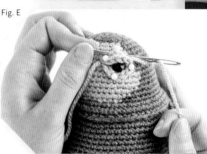

Fig. F

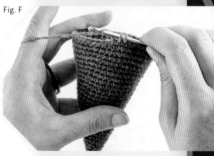

Fig. G

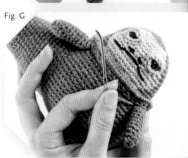

Rnd 15: [2 sc in next st, sc in next 7 st] 3 times—27 st.

Rnd 16: sc in each st around—27 st.

Rnd 17: [2 sc in next st, sc in next 8 st] 3 times—30 st.

Rnd 18: sc in each st around—30 st.

Rnd 19: [2 sc in next st, sc in next 9 st] 3 times—33 st.

Rnd 20: sc in each st around—33 st.

Rnd 21: [2 sc in next st, sc in next 10 st] 3 times—36 st.

Rnds 22–23: (2 rounds) sc in each st around—36 st.

Rnd 24: [2 sc in next st, sc in next 5 st] 6 times—42 st.

Rnds 25–28: (4 rounds) sc in each st around—42 st. (Fig. F–page 73)

• Sl st in next st then FO, leaving a length of yarn. Stuff tail and sew to Jabba's right side, making sure he will stay upright on a flat surface.

ARMS (make 2): Green yarn.

Rnd 1: ch 2, work 6 sc into first ch—6 st.

Rnd 2: [2 sc in next st, sc in next 2 st] 2 times—8 st.

Rnd 3: sc in each st around—8 st.

Rnd 4: 2 sc in next st, sc in next 7 st—9 st.

Rnds 5–10: (6 rounds) sc in each st around—9 st.

Rnd 11: [sc2tog, sc in next st] 3 times—6 st. Sl st in next st and FO, leaving a length of yarn. Stuff a little and sew to the body on either side of the face, just underneath the neck roll. (Fig. G–page 73)

• Sew the edge of the neck roll created by the increases on rnd 16 and decrease on rnd 18 so that rnd 18 is pushed up a bit to emphasize the bulge. The edge should be sewn to the body and over the tops of the arms.

• Arrange Jabba by curving his tail inward a little.

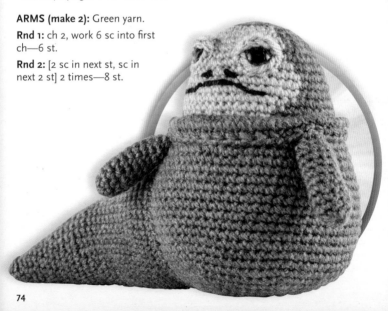

About the Author

Lucy Collin learned to crochet as a child, when she was taught by her grandmother. But it wasn't until she had children of her own and discovered she could use her slightly rusty crochet skills to create amigurumi characters and cute toys that her obsession was born. Nine years later, Lucy has combined her passion for designing creatures and characters with her love of science fiction and fantasy. She has published patterns in magazines such as *Inside Crochet* and *Crochet Gifts,* and created the patterns for the book *Hollywood Crochet*. Find Lucy on Etsy as Lucyravenscar (lucyravenscar.etsy.com) or follow her on her blog (lucyravenscar.blogspot.com). Lucy lives in West Sussex, England.

Acknowledgments

Thanks to my family for encouraging me with my crochet endeavors, and especially to my children for their enthusiasm and their helpful critiques of my designs.